T0194689

An Analysis of

Gustavo Gutiérrez's

A Theology
of Liberation

Marthe Hesselmans
with
Jonathan Teubner

Published by Macat International Ltd
24:13 Coda Centre, 189 Munster Road, London SW6 6AW.

Distributed exclusively by Routledge
2 Park Square, Milton Park, Abingdon, Oxon OX14 4RN
711 Third Avenue, New York, NY 10017, USA

Routledge is an imprint of the Taylor & Francis Group, an informa business

www.macat.com
info@macat.com

Cataloguing in Publication Data
A catalogue record for this book is available from the British Library.
Library of Congress Cataloguing-in-Publication Data is available upon request.
Cover illustration: Etienne Gilfillan

ISBN 978-1-912303-85-4 (hardback)
ISBN 978-1-912127-39-9 (paperback)
ISBN 978-1-912282-73-9 (e-book)

Notice
The information in this book is designed to orientate readers of the work under analysis,
to elucidate and contextualise its key ideas and themes, and to aid in the development
of critical thinking skills. It is not meant to be used, nor should it be used, as a
substitute for original thinking or in place of original writing or research. References and
notes are provided for informational purposes and their presence does not constitute
endorsement of the information or opinions therein. This book is presented solely for
educational purposes. It is sold on the understanding that the publisher is not engaged
to provide any scholarly advice. The publisher has made every effort to ensure that
this book is accurate and up-to-date, but makes no warranties or representations with
regard to the completeness or reliability of the information it contains. The information
and the opinions provided herein are not guaranteed or warranted to produce particular
results and may not be suitable for students of every ability. The publisher shall not be
liable for any loss, damage or disruption arising from any errors or omissions, or from
the use of this book, including, but not limited to, special, incidental, consequential or
other damages caused, or alleged to have been caused, directly or indirectly, by the
information contained within.

CONTENTS

THE MACAT LIBRARY

The Macat Library is a series of unique academic explorations of seminal works in the humanities and social sciences – books and papers that have had a significant and widely recognised impact on their disciplines. It has been created to serve as much more than just a summary of what lies between the covers of a great book. It illuminates and explores the influences on, ideas of, and impact of that book. Our goal is to offer a learning resource that encourages critical thinking and fosters a better, deeper understanding of important ideas.

Each publication is divided into three Sections: Influences, Ideas, and Impact. Each Section has four Modules. These explore every important facet of the work, and the responses to it.

This Section-Module structure makes a Macat Library book easy to use, but it has another important feature. Because each Macat book is written to the same format, it is possible (and encouraged!) to cross-reference multiple Macat books along the same lines of inquiry or research. This allows the reader to open up interesting interdisciplinary pathways.

To further aid your reading, lists of glossary terms and people mentioned are included at the end of this book (these are indicated by an asterisk [*] throughout) – as well as a list of works cited.

Macat has worked with the University of Cambridge to identify the elements of critical thinking and understand the ways in which six different skills combine to enable effective thinking.
Three allow us to fully understand a problem; three more give us the tools to solve it. Together, these six skills make up the **PACIER** model of critical thinking. They are:

ANALYSIS – understanding how an argument is built
EVALUATION – exploring the strengths and weaknesses of an argument
INTERPRETATION – understanding issues of meaning

CREATIVE THINKING – coming up with new ideas and fresh connections
PROBLEM-SOLVING – producing strong solutions
REASONING – creating strong arguments

To find out more, visit **WWW.MACAT.COM.**

CRITICAL THINKING AND *A THEOLOGY OF LIBERATION*

Primary critical thinking skill: PROBLEM SOLVING
Secondary critical thinking skill: REASONING

Peruvian priest Gustavo Gutiérrez wanted to solve the problem of how the church could conduct itself to improve the lives of the poor, while consistently positioning itself as politically neutral. Despite being a deeply religious man, Gutiérrez was extremely troubled by the lukewarm way in which Christians in general, and the Catholic Church in particular, acknowledged and supported the poor. In *A Theology of Liberation*, he asked what he knew was an awkward question, and came to an awkward answer: the Church cannot separate itself from economic and political realities.

Jesus showed his love for the poor in practical ways – healing the sick, feeding the hungry, liberating the oppressed. His example showed Gutierrez that economic, political, social and spiritual development are all deeply connected. His problem-solving prowess then led him to conclude that the church had to become politically active if it was to confront poverty and oppression across the world. For Gutierrez, the lives of the poor and oppressed directly reflect the divine life of God. As such, all Christians should work with the disadvantaged to improve their social and economic conditions.

ABOUT THE AUTHOR OF THE ORIGINAL WORK

Born in 1928, **Gustavo Gutiérrez** is a Peruvian theologian and Dominican priest who became a powerful Roman Catholic voice for social and economic justice in the late twentieth century. His modest upbringing and education in the Peruvian capital, Lima, saw him develop a belief in a Christian philosophy that truly engages with modern society and modern life.

Gutiérrez is convinced that God has a special love for the poor and oppressed, and so has written and worked to improve the lives of such people in Latin America, where he sees many economic and social injustices. Gutiérrez's ideas have inspired reform movements around the world and have changed the way in which the Roman Catholic Church approaches and talks about poverty.

ABOUT THE AUTHORS OF THE ANALYSIS

Marthe Hesselmans is a doctoral researcher in religious studies at Boston University. Her research looks at the role of religion in shaping national identities during times of social change.

Dr Jonathan Teubner holds a PhD in intellectual history from the University of Cambridge, focusing on the reception of St Augustine. He is currently Associate Director of the Initiative on Religion, Politics and Conflict at the University of Virginia.

ABOUT MACAT

GREAT WORKS FOR CRITICAL THINKING

Macat is focused on making the ideas of the world's great thinkers accessible and comprehensible to everybody, everywhere, in ways that promote the development of enhanced critical thinking skills.

It works with leading academics from the world's top universities to produce new analyses that focus on the ideas and the impact of the most influential works ever written across a wide variety of academic disciplines. Each of the works that sit at the heart of its growing library is an enduring example of great thinking. But by setting them in context – and looking at the influences that shaped their authors, as well as the responses they provoked – Macat encourages readers to look at these classics and game-changers with fresh eyes. Readers learn to think, engage and challenge their ideas, rather than simply accepting them.

'Macat offers an amazing first-of-its-kind tool for
interdisciplinary learning and research. Its focus on works
that transformed their disciplines and its rigorous approach,
drawing on the world's leading experts and educational institutions,
opens up a world-class education to anyone.'

Andreas Schleicher
Director for Education and Skills, Organisation for Economic
Co-operation and Development

'Macat is taking on some of the major challenges in university
education … They have drawn together a strong team of active
academics who are producing teaching materials that are
novel in the breadth of their approach.'

Prof Lord Broers,
former Vice-Chancellor of the University of Cambridge

'The Macat vision is exceptionally exciting. It focuses
upon new modes of learning which analyse and explain seminal texts
which have profoundly influenced world thinking and so social and
economic development. It promotes the kind of critical thinking
which is essential for any society and economy.
This is the learning of the future.'

Rt Hon Charles Clarke, former UK Secretary of State for Education

'The Macat analyses provide immediate access to the critical
conversation surrounding the books that have shaped their
respective discipline, which will make them an invaluable resource
to all of those, students and teachers, working in the field.'

Professor William Tronzo, University of California at San Diego

WAYS IN TO THE TEXT

KEY POINTS

- Gustavo Gutiérrez (b. 1928) is a Peruvian theologian* (someone who studies the nature of religious beliefs and God) and Catholic priest (Catholicism* is the largest branch of the Christian faith).

- *A Theology of Liberation* (1971) argues that the Catholic Church should work for social and economic justice in order to recognize God's love for people who are poor and oppressed* (that is, people who are unfairly prevented from having the same access to resources as others).

- Gutiérrez's work criticized the Church for focusing on salvation in a spiritual rather than economic and social way.

Who Is Gustavo Gutiérrez?

Gustavo Gutiérrez, the author of *A Theology of Liberation: History, Politics, and Salvation* (1971), is a Peruvian theologian who became a powerful Catholic voice for social and economic justice in the late twentieth century. He was born in 1928 in the Peruvian capital of Lima to a poor Hispanic-indigenous family (that is, his ancestry is both European and Native American). His education eventually introduced him to European schools of theology,

where he encountered progressive Catholic theology alongside Marxist* social thought. Marxism, which developed from the economic and political philosophy of the German economist and political philosopher Karl Marx* (1818–1883), analyzes the material conditions in which laborers work, and also attempts to empower laborers to control the production of goods. Gutiérrez's work would be informed by this combination of progressive Catholicism and Marxism.

After finishing his education in Europe, Gutiérrez returned to Lima to become a teacher and priest, and he sought to apply what he had learned to the lives of his students and parishioners. Toward the end of the 1960s, however, war broke out between revolutionary movements and several of the standing Latin American governments, including Peru's. As a consequence of the violence, the gap between the rich and the poor grew increasingly stark.

It was against this background that Gutiérrez wrote *A Theology of Liberation*. In it he argued for a new Catholic theology committed to God's special love for the poor and oppressed, and to fixing the social and economic injustices that caused Latin American communities to suffer. His work coincided with other major Christian reforms, such as the decisions of the Second Vatican Council* (a gathering of Church leaders from 1962 to 1965 whose controversial conclusions were based on the need for the Church to be more socially engaged), and the rise of progressive theologies in Western universities.

A Theology of Liberation challenged traditional Catholic theology, according to which the Church's obligations were primarily spiritual rather than social. It also coined the term "liberation theology,"* which gave a name to the various arguments for Church reform that were being made at the time. Today, we can see that liberation theology has had a major influence on mainstream Christian theology and social movements worldwide.

What Does *A Theology of Liberation* Say?

Gutiérrez argues that the Catholic Church—and Christians generally—should imitate God's love for the poor by working to improve the social and economic conditions that affect everyday people. Instead of following the classic doctrines of Catholic tradition, Gutiérrez claims, the Church must address the political and economic oppression that people who live in poverty face each day.

Gutiérrez bases his argument on what he calls God's "preferential option for the poor," which can be seen in the gospel texts that tell the story of the central figure in Christianity, Jesus Christ,* believed to be the son of God. Gutiérrez argues that the lives of the poor and oppressed reflect the divine life of God, and that Christians who look to the poor can better understand God.

Central to Gutiérrez's theology is the notion that God holds a preferential love for those suffering from deprivation, not because they are better than others, but simply because they are poor and oppressed. Readers should see this focus on the poor as rooted in the specific social context of Latin America. Gutiérrez wanted the Latin American poor to be agents in their own process of liberation. As the Brazilian theologian and Catholic priest Leonardo Boff* puts it, Gutiérrez "demonstrates the transition from a modern progressive theology, characteristic of the First World, to a theology of liberation, typical of Latin America and regions that live under global exploitation."[1] That is, Gutiérrez believed the Church needed to shift its perspective from the wealthy and privileged to the impoverished.

Gutiérrez's work offers a window into the turbulent world of Latin America in the 1960s, and it can tell us about how the Catholic Church changed during the twentieth century. It has also played a critical role in launching the liberation theology movement, which has powerfully influenced the theological debates of the past 40 years. Gutiérrez's ideas have been instrumental in changing Christian belief, as well as in encouraging Catholic leaders

to pay more attention to the poor in their communities.[2] Even such a major figure as Pope Francis,* the current head of the Catholic Church, regularly draws on liberation theology.

Gutiérrez's ideas have also spread beyond the Catholic world, inspiring a wide range of activist groups and social movements. These include black,* feminist,* and American Indian* liberation theologies—which draw on theological sources to combat inequality and oppression for black people, women, and indigenous Americans respectively—and even Occupy Wall Street* (a protest movement that emerged in late 2011 in response to banking policies that were responsible for the 2007–8 economic recession in the United States).

Why Does *A Theology of Liberation* Matter?

A Theology of Liberation offers valuable insights into the complexity of human problems. In Gutiérrez's terms, economic, political, social, and spiritual flourishing are deeply connected. Therefore, the Church cannot separate itself from economic and political realities, since these are inseparable from spiritual realities. The best support for the idea of "liberation" can be found in the Christian gospels, which show Christ's concerns with healing the sick, feeding the hungry, freeing the oppressed, and restoring dignity to people on the margins of society. In sum, Gutiérrez argues that theology must take into account the full experience of human life—especially that of the people who experience poverty and oppression. In the twenty-first century, many people believe that issues of human rights are best approached in this way.

A Theology of Liberation is also important to a range of academic disciplines. Students of religion in particular may benefit from considering the economic situation that shaped Latin American society in the 1960s, and in doing so, they may be better prepared to consider how today's economy affects the lives of people around the world. Students of history may benefit from learning about

the changing attitudes of the Church in the twentieth century, a century that is often regarded as being nonreligious. Students of economics and politics may appreciate the application of Marxism to Catholic theology—a move that seemed radical in 1971, but which has become increasingly commonplace.

A Theology of Liberation can also show us how the world has changed. Latin American nations have moved toward democratic governments, and the Church is far more energized by social concerns today than it was in the 1970s. Although there have been many reasons for these changes, Gutiérrez's work in particular contributed to reshaping the Church's position, and to introducing positive changes into Latin American society. *A Theology of Liberation* thus shows that theological work can be influential both in its own time and in the years that follow.

NOTES

1 Leonardo Boff, "The Originality of the Theology of Liberation," in *The Future of Liberation Theology: Essays in Honour of Gustavo Gutiérrez*, ed. Marc H. Ellis and Otto Maduro (Maryknoll, NY: Orbis Books, 1989), 46.

2 Carol A. Drogus, "The Rise and Decline of Liberation Theology: Churches, Faith, and Political Change in Latin America," *Comparative Politics* 27, no. 4 (1995): 471.

SECTION 1
INFLUENCES

MODULE 1
THE AUTHOR AND THE HISTORICAL CONTEXT

KEY POINTS

- *A Theology of Liberation* argues that the Catholic Church* — the largest branch of the Christian faith—is obligated to address everyday social and economic injustices.

- Gutiérrez's work coincided with that of other Catholic thinkers who were already considering how the Church might better engage with society.

- Gutiérrez's early experiences with economic disparity in the Peruvian capital, Lima, and with unjust Latin American regimes encouraged him to confront problems of poverty and injustice.

Why Read This Text?

Since its publication in 1971, Gustavo Gutierrez's *A Theology of Liberation: History, Politics, and Salvation* has been considered groundbreaking both in Latin American Catholic thought and beyond. The book challenged the Catholic Church to confront pressing social and economic issues in the modern world, especially those that affected people living in poverty.

Gutiérrez's text speaks to the realities of Peruvian society in the 1950s and 1960s—where there was a huge divide between the rich and the poor. It can also teach readers about the violent clashes between revolutionaries and unjust dictatorships during this time.

Gutiérrez's theology* addressed the problems of Peru and of other developing countries* (that is, countries in which firm economic and political structures hadn't yet been established). Gutiérrez did not call

> ❝ It seemed important to me to take up themes in my classes that would allow an examination of the meaning of human existence and the presence of God in the world in which my students lived. ❞
>
> Gustavo Gutiérrez, in Robert McAfee Brown, *Gustavo Gutiérrez: An Introduction to Liberation Theology*

for military revolution, nor did he advocate violence. "Liberation" meant radical change that began with those who struggled most with the economic conditions in which they lived.

Although *A Theology of Liberation* was written about Peruvian society, its ideas were quickly adopted by readers, particularly clergy and students, across North America and Europe who were also concerned with social and economic injustices. Even today, his work continues to inspire movements for social change both inside and outside the Catholic Church.

Author's Life

Gustavo Gutiérrez was born in 1928 in Lima, Peru into a family of European and indigenous descent. He grew up in one of Lima's many impoverished neighborhoods, known as *barrios*, and suffered from illness throughout his childhood.

His experience with poverty encouraged Gutiérrez to pursue education. He joined the Dominican Order—a religious order of priests founded in the fifteenth century, with a tradition of intellectual rigor—and studied medicine and literature. Later, he left Peru for Europe to continue his education. He studied psychology and philosophy in Belgium, and did his doctoral work in theology in France.

During his time in Europe, Gutiérrez became interested in progressive Catholic theology, sometimes called *Nouvelle Théologie*, "New Theology."* This theological movement, which called for

Christian philosophy to engage with modern society, had emerged in the middle of the twentieth century in France and Germany. Its supporters criticized the Catholic Church for following doctrines that, they argued, dated from the third century. Instead, they urged the Church to engage with modern life.

When he returned to Peru, Gutiérrez began teaching at the Catholic University in Lima, and he hoped that his New Theological methods would invigorate his classes. He wanted his students to explore the meaning of their lives, and to recognize the work of God in their own daily experiences in Lima.[1]

Author's Background

In the 1950s and 1960s, Peruvian society was, economically speaking, in a state of "dialectical extremes"[2]—that is, it was starkly divided between rich and poor. Generally speaking, a small ruling class of people with mostly Hispanic (Spanish-speaking European) ancestry controlled much of the country's wealth, while a large number of indigenous or mixed-ethnicity Peruvians lived in destitution, or poverty. Corruption and human rights abuses were rampant.

This situation became even worse under the military rule that began in 1968 and lasted until 1980. A number of revolutionary movements also arose during this time both in Peru and in neighboring countries; these movements were often inspired by Marxism* (a political and economic theory of the struggle between classes to control labor and production), and tried to oust military rulers and dictatorships in conflicts that often resulted in violence.

It was against this background of social upheaval that Gutiérrez wrote *A Theology of Liberation*. He had spent the 1960s teaching and preaching in the *barrios* of Lima, and he had also travelled extensively. He had been in contact with a range of Latin American thinkers, such as José Carlos Mariàtegui,* the writer and journalist who co-founded Peru's Socialist Party, and José Maria Arguedas,* a

novelist who wrote about indigenous communities and culture. The conversations he had with such people led Gutiérrez to think about how poverty and oppression* in the region might be overcome.

The book's title demonstrates Gutiérrez's belief that the problems of Peru and other developing countries could be addressed theologically. By "liberation," Gutiérrez meant that he wanted neither a violent revolution nor gradual development towards progress led by his country's military. Liberation instead meant a radical change brought about by those who were most victimized by social and economic conditions. "In order for this liberation to be authentic and complete," Gutiérrez argued, "it has to be undertaken by the oppressed themselves."[3] He expected those living in better circumstances to join with the poor in the struggle against oppression.

NOTES

1 Robert McAfee Brown, *Gustavo Gutiérrez: An Introduction to Liberation Theology* (Maryknoll, NY: Orbis Books, 1990), 25.

2 Curt Cadorette, *From the Heart of the People: The Theology of Gustavo Gutiérrez* (Oak Park, IL: Meyer Stone Books, 1988), 2.

3 Gutiérrez, *A Theology of Liberation*, 57.

ACADEMIC CONTEXT

KEY POINTS

- By the 1960s, Christian theologians* and leaders had begun to reconsider how Catholicism* should confront pressing social issues.

- The Second Vatican Council* and the New Theology* both represented efforts to reconcile Catholic tradition with current affairs.

- During this time, Gustavo Gutiérrez was applying his New Theological training to his work as a Catholic priest in the Dominican Order in Lima, Peru.

The Work in its Context

In the early twentieth century, the Church still tended to separate its theology from worldly concerns. Church leaders and scholars were more concerned with interpreting historical religious texts and sacred doctrine than with people's everyday experiences. However, during the time in which Gustavo Gutiérrez was writing *A Theology of Liberation: History, Politics, and Salvation,* the Church's priorities were beginning to shift.

New intellectual movements argued that the Church should become more engaged with issues of the modern world. This argument gave birth to academic schools such as the *Nouvelle Théologie* (New Theology) in France and Germany, and culminated in the Second Vatican Council held in Rome from 1962 to 1965. The Council affirmed "the historical presence of God in the world rather than a high God that could not be immersed in human affairs."[1]

> ❝ The Catholic Church can be compared to a zoo
> of wild beasts, held captive for over a millennium,
> whose bars Pope John removed. There are as many
> new pacifists among the rampaging animals as there
> are liturgical innovators and structural reformists. ❞
>
> Francine du Plessix Gray, *Divine Disobedience: Profiles in Catholic Radicalism*

The intellectual climate in Latin America, where Gutiérrez lived and worked, was also changing. There were intense debates in the 1960s between proponents of capitalism* (a theory and system of government that called for open markets and for businesses and manufacturing to be privately owned) and proponents of communism* (a social philosophy that argued for the shared ownership of businesses and manufacturing for the sake of the common good).

Communists believed that a profit-driven capitalist system would result in some people having more access to wealth than others. Their system instead called for workers to own the production and distribution of goods. This system was based on Marxism,* the economic and social philosophy of the German political philosopher and economist Karl Marx,* which was becoming influential in Latin American intellectual circles. The 1959 Cuban Revolution,* in which the dictator Fulgencio Batista* was ousted by the revolutionary group 26th of July (led by the future Cuban leader Fidel Castro), was one product of communist thought.

In summary, Gutiérrez's theology aligned with the major social shifts occurring in both the Catholic Church and Latin America.

Overview of the Field

The teachings of the philosopher Karl Marx had an enormous influence on twentieth-century thinking about society and

economics. Marx's writing on communism in the nineteenth century had introduced the idea of social classes struggling to control the production of goods. Marx had also called for social reforms that empowered the working classes. Marx's teachings were taken up by revolutionary political movements, and they also informed academics in many different disciplines.

That said, Marxist thought was not always welcomed by religious institutions. Many in the Catholic Church, for example, staunchly opposed its principles. It wasn't until the middle of the twentieth century that progressive European theologians who had taken up Marxist ideas began to assert their influence in turning the Church's attention to the concerns of everyday people.

In France and Germany, these concerns produced New Theology, a movement that engaged critically with the third- and fourth-century Christian doctrines—sets of beliefs—that still dictated much Church tradition. The New Theologians wanted instead a Christian theology that was better engaged with the intellectual, social, and economic realities of modern life. This sort of progressive theological movement amounted to a critique of the Church's stance against modernity.

Academic Influences

Marxist thought was not the only important influence on Central and South American intellectuals and revolutionaries during the 1960s. Other thinkers who emphasized empowering the masses were also significant. One such example was the Brazilian writer and educator Paulo Freire,* who worked to improve literacy among those who struggled against social and economic injustice. In *A Theology of Liberation*, Gutiérrez pays tribute to Freire's famous book *Pedagogy of the Oppressed*, calling it "one of the most creative and fruitful efforts implemented in Latin America."[2]

Latin American thinkers such as the journalist and co-founder

of Peru's Socialist Party José Carlos Mariàtegui* and novelist José Maria Arguedas* also supported socialist and Marxist thought. Their writing helped Gutiérrez become aware of the class struggle raging through Peru and its neighboring countries. They also encouraged him to see this struggle through the eyes of the poor. In Peru, those most affected by economic and social conditions were the indigenous populations.

Additionally, Gutiérrez's European education and theological training exposed him to the teachings of New Theology. Gutiérrez studied under several key New Theology thinkers, such as the Jesuit priest Henri de Lubac* and the French Dominican theologian Yves Congar,* both of whom were directly involved in the Second Vatican Council. Scholars like these provided Gutiérrez with a theology that combined Church teachings and practices with social and economic concerns.

NOTES

1 Mario I. Aguilar, "Religion, Politics and Liberation: A Dialogue between Gustavo Gutiérrez, the 14th Dalai Lama and Gianni Vattimo," *Political Theology* 12, no. 1 (2011): 146.

2 Gustavo Gutiérrez, *A Theology of Liberation: History, Politics, and Salvation,* trans. and ed. Caridad Inda and John Eagleson (Maryknoll, NY: Orbis Books, 2009), 57.

MODULE 3
THE PROBLEM

KEY POINTS

- Christian theologians* and Church leaders wanted to develop a way for Christians to respond to poverty and oppression.*

- Progressive theologians,* especially in Latin America, were influenced by the political and economic philosophy of Marxism* and sought to join revolutionary movements; however, many conservative theologians thought that the Church* should remain neutral.

- Gutiérrez, as a progressive theologian, believed that the Church should support poor and oppressed peoples, but he did not endorse violent revolutions.

Core Question

In *A Theology of Liberation: History, Politics, and Salvation,* Gustavo Gutiérrez is mainly concerned with those who suffer from poverty and oppression, particularly in Latin America. Throughout the book, he develops an answer to the question of what constitutes a suitable Christian response to these conditions. How should Christians, and more specifically the Catholic Church, address injustice and an unfair distribution of resources?

This question was a challenge to traditional Catholic thinking, which had focused on spirituality and religious doctrine. When it came to politics and society, the Catholic Church and its pastors and theologians were supposed to be neutral. This mentality, according to Gutiérrez, generated "pastoral attitudes out of touch with reality."[1]

However, following the publication of *A Theology of Liberation*

> **❝** The Latin American bishops cannot remain indifferent in the face of the tremendous social injustices existent in Latin America, which keep the majority of our peoples in dismal poverty, which in many cases becomes inhuman wretchedness. **❞**
>
> "Poverty of the Church," Latin American Bishops' joint declaration in Medellín, Colombia, 1968

in 1971, this traditional line of thinking began to lose support. In theology schools across Europe, scholars developed theologies that were more engaged with the modern world. This shift in thinking culminated in the Second Vatican Council,* a gathering of Church leaders that took place between 1962 and 1965 with the purpose of formulating a clear position for how the Catholic Church should relate to contemporary society.

The Participants

In the 1950s and 1960s, members of the Latin American Catholic community began to call for the Catholic Church to address the region's pervasive poverty. This movement is often associated with the 1968 Bishops' Conference in Colombia's second-largest city, Medellín, during which Latin American bishops produced a statement urging the Catholic Church to work for social and economic justice in their region.

We can see Gutiérrez's work as a culmination of this sort of Latin American Catholic thinking. He draws from both biblical and historical sources and from major Church publications of the time. Gutiérrez also refers to the proceedings of the Second Vatican Council to show that its argument is part of a larger trend in which those in Latin America and Europe critiqued the Church's stance on social and political issues.

The Second Vatican Council initiated a great deal of debate

within the Church community. Progressive Church intellectuals who supported a socially engaged position clashed with conservatives who wanted to remain neutral and stay uninvolved in political activism.

In Latin America, a small but vigorous group of reformist theologians advocated for the Church to take on issues of poverty and inequality. In addition to Gutiérrez, leaders in this movement included Juan Luis Segundo,* a Uruguayan Jesuit priest; Leonardo Boff,* a Brazilian Catholic theologian who was an early proponent of liberation theology;* and sociologist and theologian Hugo Assman,* who is best known for his work *Theology from the Praxis of Liberation*.

The Contemporary Debate

Gutiérrez has been described as "fairly representative" of the group of Latin American theologians that fuelled the reformist movement within the Church.[2] Like Boff, Segundo, and Assman, Gutiérrez grew up in an urban lower-to-middle-class environment, was educated in Europe, and was deeply dissatisfied with the Catholic Church's policies in Latin America.

One of the groups' main complaints was that the Church had supported existing authoritarian and elitist systems in the region—systems in which the government exercised total authority over the lives of the citizens, or in which a small elite enjoyed status, power, and prosperity. It had never really been the neutral institution that conservatives claimed it was. The reformist theologians believed that the time had come for the Church to take the side of the poor and oppressed. This position was often informed by Marxist thought, which itself called for empowering the working classes.

Some reformers even joined emerging revolutionary movements that sought to overthrow existing governments and replace them with socialist systems. One such example was Gutiérrez's friend

and fellow priest, Camilo Torres,* who died as guerrilla fighter in Colombia in 1966.

Gutiérrez was significantly influenced by reformist discussions. *A Theology of Liberation* reflects the movement's stance on what the Church should do in response to poverty, and Gutiérrez included references to Karl Marx's* writing on social and economic philosophy. Especially important for Gutiérrez was Marx's belief in "an era in history when humankind can live humanly,"[3] which supported the conviction that God wanted the poor to be liberated. A politically engaged Church would have contributed greatly to such change.

One important distinction between Gutiérrez and other radical Marxist thinkers in his circle was that Gutiérrez did not recommend violent revolution. Instead, he hoped to convince the Church to reform through profound theological arguments.

NOTES

1 Gustavo Gutiérrez, *A Theology of Liberation: History, Politics, and Salvation,* trans. and ed. Caridad Inda and John Eagleson (Maryknoll, NY: Orbis Books, 2009), 35.

2 Jeffrey L. Klaiber, "Prophets and Populists: Liberation Theology, 1968–1988," *The Americas* 46, no. 1 (1989): 3.

3 Gutiérrez, *A Theology of Liberation*, 19.

THE AUTHOR'S CONTRIBUTION

KEY POINTS

- Gustavo Gutiérrez proposed that to be Christian meant to understand what it is to suffer from hardship.

- This proposal reversed the traditional Catholic* doctrine by beginning with everyday experience and the possibility of salvation within human history instead of with doctrines of faith.

- *A Theology of Liberation* also offered a sophisticated biblical argument and proposals for how the Church should take action.

Author's Aims

The theology of liberation,* the concept developed by Gustavo Gutiérrez in *A Theology of Liberation: History, Politics, and Salvation*, was a new conception of the Catholic tradition involving the study of the nature and identity of God. Primarily concerned with lives of ordinary people, liberation theology differed significantly from traditional theology,* which focused on religious doctrines of the past.

Gutiérrez proposes that Christians should reflect on the Bible and on the faith of those committed to the struggle for liberation—that is, the struggle for freedom from oppressive* systems of government and economics. He encourages Christians to view their faith through the eyes of those suffering from hardship and to work toward a state of communion. This state of communion is the salvation, or liberation, that Gutiérrez believes will take place within human history. This theological approach is intended to recognize people's struggles against oppression, and to make Christians aware of God's

> ❝ Because liberation theology takes a critical approach, it refuses to serve as a Christian justification of positions already taken ... [U]nless we make an ongoing commitment to the poor ... we are far removed from the Christian message. ❞
>
> Gustavo Gutiérrez, *A Theology of Liberation: History, Politics, and Salvation*

desire for humankind to be free from injustice and domination.

A Theology of Liberation is organized into three parts. Gutiérrez begins with a critical discussion of past and current theologies, which he believes have failed to address the real-world problems that people face.

Next, Gutiérrez delves more deeply into the Latin American context. He believed that Latin American Christians needed "a greater knowledge of the current Latin American reality,"[1] so that they could understand the state of deprivation in which many people lived. He acknowledges that the Church has attempted to respond to these problems, but ultimately argues that many of them remain unresolved.

Finally, Gutiérrez offers an extensive theological argument, rooted in biblical sources and Christian publications, for why and how the Latin American Church and Christians across the world should join the struggle for liberation. He also suggests a few concrete revisions for Christian practice.

Approach

Important to understanding *A Theology of Liberation* are the ideas that God holds a special love for the poor, and that the Church's actions and policies should reflect that love. To clarify what he means by "the poor," Gutiérrez distinguishes between material poverty, spiritual poverty, and "poverty as a commitment of solidarity and protest."[2]

He calls material poverty an "early and unjust death" and a "scandalous condition"[3] caused by unfair economic and social systems. Spiritual poverty means being able to truly welcome God into one's life with the openness of a child. Finally, voluntary poverty can be an act of solidarity and even liberation when it comes in the form of full and voluntary love for one's neighbor. By voluntarily becoming poor, people can have a better understanding of their neighbors' conditions, and therefore can better understand God's love.

Gutiérrez's proposals present a challenge for the Catholic Church. He called this challenge "uncentering,"[4] by which he meant that the Church should shift its focus from heavenly salvation to earthly salvation, and in so doing, serve people in immediate need. The Church, he further contends, should itself become poor to reflect God's special love for the poor.

It is important to understand that these were not new ideas. Gutiérrez drew from a particular line of Catholic thinking that was developing in Europe and Latin America in the 1950s and 1960s. This new reform movement emphasized the need for the Church to stand by those living in poverty. Gutiérrez added to this emerging argument a sophisticated Bible-based theology. He also went further in arguing for concrete Church action to liberate the poor.

Although he had directly challenged the Catholic Church, his arguments were quickly embraced by local Latin American Catholic action groups that had been gaining popularity in Latin America. These grassroots groups were made up of Christians who wanted their Church to be more progressive and to serve Latin America's deprived communities. Gutiérrez was inspired by these activist groups, and inspired them in return through *A Theology of Liberation*.

Contribution in Context

A Theology of Liberation builds on important ideas beginning to change the Catholic Church in the 1950s and 1960s. Two sources of ideas

were particularly important—namely, those from theological schools in Europe that sought to engage more with modern society, and those articulated by the Latin American Catholic Church in response to the region's impoverished populations.

Gutiérrez had been exposed to the European reform movement while studying at the Faculty of Theology in Lyon, France between 1955 and 1959. There, he encountered a range of progressive European theologians, such as the French Jesuit priest Henri de Lubac,* who helped shape the Second Vatican Council,* and Yves Congar,* a French theologian of the Dominican Order who was committed to turning the Church's vision toward the modern world.

When he returned to Latin America, Gutiérrez joined such Catholic intellectuals as the Brazilian theologian Leonardo Boff* and the priest and eventual communist rebel Camilo Torres* who, along with other Latin American Church leaders, were eager to make the Church more responsive to the widespread poverty of their region. These encounters helped Gutiérrez develop his ideas.

When *A Theology of Liberation* appeared in 1971, it quickly became a core text of the progressive Latin American Church movement. The book also coined the term "liberation theology." Naming the concept made it easier for Catholic and liberal Protestant* intellectuals to use it in debate (Protestantism is a branch of Christianity that broke from the Catholic Church in the sixteenth century).[5]

NOTES

1 Gustavo Gutiérrez, *A Theology of Liberation: History, Politics, and Salvation,* trans. and ed. Caridad Inda and John Eagleson (Maryknoll, NY: Orbis Books, 2009), 58.

2 Gutiérrez, *A Theology of Liberation,* 171.

3 Gutiérrez, *A Theology of Liberation,* 165.

4 Gutiérrez, *A Theology of Liberation,* 143.

5 Jeffrey L. Klaiber, "Prophets and Populists: Liberation Theology, 1968–1988," *The Americas* 46, no. 1 (1989): 5.

SECTION 2
IDEAS

MAIN IDEAS

KEY POINTS

- *Gutiérrez's A Theology of Liberation* has four central themes: critical reflection; liberation from oppression;* God's love for the poor; and the Church's commitment to social justice.

- Gutiérrez argues that the Church should reflect God's special love for the poor by working toward changes that will improve their lives.

- He also adds a critical interpretation of Scripture*—that is, holy Christian texts—to demonstrate that both God and Jesus Christ* were in solidarity with the poor, and that therefore the Church should be too.

Key Themes

In *A Theology of Liberation: History, Politics, and Salvation*, Gustavo Gutiérrez outlines a new theology* that responds to the conditions of the oppressed in Latin America and beyond. His new approach, which he calls liberation theology,* reflects a Christian faith that is committed to liberating the poor and ending injustice. Four central themes emerge here: critical reflection; liberation from oppression; God's love for the poor; and the Church's active commitment to justice.

Critical thinking and reflection are crucial parts of Gutiérrez's theology. Specifically, he advocates a theology informed by the idea of praxis,* or a combination of reflection and action. He argues for a focus on the "experience and meaning of faith,"[1] and says that theology should begin with human action, rather than abstract doctrine. This means closely examining human history and the conditions of contemporary society.

> ❝ To be a Christian is to accept and to live ... the meaning that the Word of the Lord and our encounter with that Word give to the historical becoming of humankind on the way toward total communion. ❞
>
> Gustavo Gutiérrez, *A Theology of Liberation: History, Politics, and Salvation*

This sort of reflection, Gutiérrez believes, is liberating. A consideration of how history contributes to actual events helps to reveal their true meaning as willed by God. Knowing what God intends will help people realize that they do not have to accept injustice and deprivation, since that is not how God meant them to live. This is an important step in the process of liberation.

The other major themes are extensions of critical reflection. Gutiérrez continually stresses that God wants people to be free of material deprivation. This reflects God's love for the poor. Such liberation requires uncompromising solidarity with the poor from both the Church and individual Christians. This means fostering societal and social changes that will lead to justice and economic equality.

Exploring the Ideas

The four themes of Gutiérrez's theology are deeply intertwined. Critical reflection is required for people to understand and act in accordance with God's love for the poor, but it is only through Church action that liberation can be accomplished.

First, *A Theology of Liberation* calls for critical theological reflection, which is a requirement for the process of liberation. For Gutiérrez, this involves a critical reading of the Bible coupled with a close analysis of social reality. In this way, theology can help deepen our understanding of God's plan and raise awareness of God's commitment to liberating the poor.

The idea that God has a special love for the poor is threaded

throughout *A Theology of Liberation*. By "special," Gutiérrez does not mean that God thinks the poor are better than other classes; rather, he means that they receive preferential love because they have been robbed of compensation for their work, and suffer from political, social, economic, or cultural oppression.

In Gutiérrez's view, in this way the poor show that God's love is infinite. He later clarified that by "preference," he did not mean "exclusive," but rather that he wanted "to call attention to those who are the first—though not the only ones—with whom we should be in solidarity."[2]

Furthermore, he argued that the Church must commit to acting for justice for the world's poor. He reasons that the Kingdom of God is at hand and "necessarily implies the reestablishment of justice in this world."[3] The idea that God's "will be done in earth, as it is in heaven"[4] is not something that might happen only at the end of time, but rather it might apply to all of human history. It will not be achieved unless the Church and each individual Christian work toward it by striving for the liberation of the oppressed.

Liberation, for Gutiérrez, means freeing humanity from sin—the ultimate root of injustice. Liberation cannot be achieved, however, without radical change. This is the responsibility not only of politicians, but also (if not especially) of the Church and every Christian.

Language and Expression

Initially, *A Theology of Liberation* reached mostly other clergy or theologians across the Atlantic rather than the Latin American poor themselves. This is because the book is an in-depth exploration of complicated theological issues, and Gutiérrez uses the scholarly, theoretical language of Catholic Church history and tradition. This meant that Gutiérrez's work was most naturally suited to an academic, theological readership; other readers are less likely to be familiar with the book's vocabulary.

This is why the book was regarded by some as "less a reflection on the reality of Latin America than a dialogue with Europe and America":[5] Gutiérrez may have intended it to speak to those who were educated and in positions of power, and who therefore had the ability to effect change. Some consider this a weakness of the text— the book contains few concrete suggestions for implementing its central concepts.

One important contribution it did make, however, was to introduce the term "liberation theology," a concept that had previously been outlined but not yet given a name. It not only influenced Latin American Catholics,* but also, in the words of the priest and historian Jeffrey Klaiber,* "consecrated the term [liberation theology] and made the concept a topic of debate in Catholic and liberal Protestant* intellectual circles in both the First and the Third Worlds."[6]

This shows how, in spite of its challenging vocabulary, Gutiérrez's writing still managed to inspire a wide audience. It has encouraged scholars, activists, Christians, and non-Christians across the world to seek solidarity with the poor and to work towards an end to oppression.

NOTES

1 Gustavo Gutiérrez, *A Theology of Liberation: History, Politics, and Salvation,* trans. and ed. Caridad Inda and John Eagleson (Maryknoll, NY: Orbis Books, 2009), 174.

2 Gutiérrez, *A Theology of Liberation,* xxvi,

3 Gutiérrez, *A Theology of Liberation,* 171.

4 *King James Bible* (Champaign, IL: Project Gutenberg, 1990), Book 40, Matthew, 6:10.

5 Jeffrey L. Klaiber, "Prophets and Populists: Liberation Theology, 1968–1988." *The Americas* 46.1 (1989): 9.

6 Klaiber, "Prophets and Populists." 5.

MODULE 6
SECONDARY IDEAS

KEY POINTS

- Two other important ideas in *A Theology of Liberation* are "integral liberation," which includes both socioeconomic *and* personal transformation, and critical Bible reading, which notes the calls for social justice in biblical texts.

- These ideas helped Gutiérrez develop his message of urgent Christian obligation—the notion that Christians were obliged to attend to matters concerning social justice.

- Gutiérrez's critical Bible reading offered a radically new interpretation of the Christian gospels.

Other Ideas

Gustavo Gutiérrez, the author of *A Theology of Liberation: History, Politics, and Salvation,* is said to have given the name "liberation theology"*[1] to an important shift occurring in mid-twentieth-century Catholic* thinking. Two of the author's secondary ideas may help us to better understand what liberation theology meant. One is "integral liberation," which refers to Gutiérrez's idea of a more comprehensive, holistic kind of liberation (that is, a liberation achieved by successfully addressing differing but interdependent forms of oppression*). Another is critical Bible reading, or Gutiérrez's call for readers to recognize the Bible's call for social justice.

The idea of "integral liberation" has to do with the urgent need for human liberation around the world. Gutiérrez called for the Latin American people to be directly engaged in radical change in the struggle against poverty and oppression. "Critical Bible

> **❝** Only by participating in the historical process of liberation will it be possible to show the fundamental alienation present in every partial alienation. This radical liberation is the gift which Christ offers us. By his death and resurrection he redeems us from sin and all its consequences ... This is why the Christian life is a Passover, a transition from sin to grace, from death to life, from injustice to justice, from the subhuman to the human. Christ introduces us by the gift of his Spirit into communion with God and with all human beings. **❞**
>
> Gustavo Gutiérrez, *A Theology of Liberation: History, Politics, and Salvation*

reading" calls for a similarly urgent change in how Christians read Scripture.* Reading the Bible critically, Gutiérrez believed, would help raise awareness of God's goal for social justice in the world, and it would also convince the Church to do more to support the poor.

Both ideas are an important part of the liberation process and are intended to apply to all Christians, even those who do not think of themselves as oppressed. As such, Gutiérrez connects them with key debates of the 1960s and 1970s, such as whether developing countries* should follow in the footsteps of countries like the United States in progressing toward modernity. Gutiérrez worried that "progress" for Latin American countries would only make them dependent on richer countries.

Both ideas—integral liberation and critical Bible reading— have become important for theologians* and students of religion. They have been used to change the way both the Church and academics talk about and relate to the poor.

Exploring the Ideas

Gutiérrez believed that liberation was a complicated notion, and he used the term "integral liberation" to demonstrate this. Integral liberation is divided into three stages. First is liberation from situations in which people are socially or economically marginalized. Second, people must undergo personal transformations toward inner freedom, love, and fellowship. Finally, people must be liberated from structural oppression, or oppression caused by an economy or system of government in which some groups have an advantage over others. Structural oppression, Gutiérrez claims, is the ultimate sin and the root of all oppression. It should also be noted that Gutiérrez believed that liberation should take place in our time—not in the afterlife.

Critical Bible reading meant grounding the discussion of liberation in scriptural sources (in Christian terms, the texts of the Bible). Gutiérrez calls for readers to closely examine religious texts and to understand what they say about social justice. This sort of reading would reveal that in offering Jesus Christ,* whom Christians believe to be God's son, as a liberator, God intended to free humanity from sins (such as oppression). Christ saves humankind from injustice because "he enables us to live in communion with him" and thus forms the "basis for all human fellowship."[2]

Salvation, however, is not something people can achieve, but rather is a continuous process that people must fulfill each day. Accordingly, Bible reading should be linked to the realities of living people, and theologians should relate their religious study to people's daily struggles against oppression. This might also mean actively participating in those struggles. Or, as Gutiérrez himself puts it, a theology of liberation should "recognize the work and importance of concrete behavior, of deeds, of action, of praxis* in the Christian life."[3]

Overlooked

Initially, readers of *A Theology of Liberation* focused on what its social and political arguments meant for the Catholic Church.* Only recently has attention been paid to the to the book's spiritual underpinning. One reason for this new focus has been Gutiérrez's own reinterpretation of liberation theology. The Christian philosopher Arthur McGovern* noted this shift in 1989 when he wrote that "the revolutionary excitement has dimmed" and that "Gutiérrez has devoted much of his time and writings to the question of spirituality."[4]

We can glean the importance of spirituality to the book in Gutiérrez's idea that "concrete history is the place where God reveals the mystery of God's personhood."[5] By this he means that people develop a relationship with God by becoming closely involved with the circumstances in which they live, such as the conditions that lead to oppression. In the chapter "Encountering God in History," Gutiérrez argues for a spirituality that "will center on a *conversion* to the neighbor, the oppressed person."[6] Only by engaging with those living in poverty and by experiencing their perspective does Gutiérrez believe we can truly meet God and thus achieve our own liberation.

Since the 1990s, commentators on Gutiérrez have increasingly noted the spiritual dimensions of his work, particularly in his later writing. But readers of *A Theology of Liberation* should remember that no matter how important spirituality becomes to interpreting Gutiérrez, the author's theology demands that faith be connected to actual worldly affairs.

NOTES

1 Jeffrey L. Klaiber, "Prophets and Populists: Liberation Theology, 1968–1988," *The Americas* 46, no. 1 (1989): 5.

2 Gustavo Gutiérrez, *A Theology of Liberation: History, Politics, and Salvation,* trans. and ed. Caridad Inda and John Eagleson (Maryknoll, NY: Orbis Books, 2009), 25.

3 Gutiérrez, *A Theology of Liberation,* 8.

4 Arthur McGovern, *Liberation Theology and Its Critics: Toward an Assessment* (Maryknoll, NY: Orbis Books, 1989), 87.

5 Gustavo Gutiérrez, *The Power of the Poor in History: Selected Writings* (Maryknoll, NY: Orbis Books, 1983), 52.

6 Gutiérrez, *A Theology of Liberation,* 118.

ACHIEVEMENT

KEY POINTS

- Since its publication over 40 years ago, *A Theology of Liberation* has played an important role in launching the movement of liberation theology,* which has in turn powerfully shaped how Christian Churches talk about and relate to the poor.

- Gutiérrez's challenge to the Catholic Church,* though initially controversial, has more recently shaped the concerns of popes—the heads of the Catholic Church—and other Catholic leaders.

- The academic style of *A Theology of Liberation* made it less popular among nonacademic and nonreligious readers.

Assessing the Argument

Gustavo Gutiérrez's *A Theology of Liberation: History, Politics, and Salvation* has been well received by those who study theology,* in particular clergy and scholars associated with the Catholic Church. Gutiérrez's liberation ideas are believed to have influenced Catholic leaders, both in Latin America and in the world generally, leading to them paying more attention to the poor in their communities. Today, it is unlikely that the Church as a whole would revert to its practices before the advent of liberation theology.

The book was especially well received by Latin American theologians, most of whom were Catholic. Many considered it a foundational work for the movement they had helped to form.[1] Additionally, many liberal Protestant* thinkers were also inspired by Gutiérrez's vision, scriptural interpretation, and calls for the Church

> 66 Gutierrez's groundbreaking work, *A Theology of Liberation*, published in 1971, changed everything. It seemed to chart a whole new course for the church, not just for Latin America, but everywhere. Vatican II* challenged scholars to renew their theology and biblical study. Gutierrez responded by examining our concept of God and the scriptures* within the Latin American reality of extreme poverty and systemic injustice. That led to a renewed realization of Christ's presence among the poor and oppressed, especially in their struggle to end poverty and oppression. 99
>
> John Dear, "Gustavo Gutiérrez and the Preferential Option for the Poor," *National Catholic Reporter*

to take action. The American theologian Frederick Herzog,* who is known for his civil rights work, believed that Gutiérrez's ideas, and especially his emphasis on God as justice, have been a valuable addition to Christian thought in the United States.[2]

Gutiérrez's ideas have also spread beyond the Catholic world. More than forty years after *A Theology of Liberation* was published, a wide range of groups and social movements is drawing inspiration from the book, such as those espousing black,* feminist,* and American Indian* liberation theologies. These groups use Gutiérrez's methods and theory to resist and struggle against the various types of oppression* they face (in this case, the struggles of people of African ancestry, women, and indigenous Americans).

Achievement in Context

When *A Theology of Liberation* first appeared in 1971, it shocked the Catholic world with its new approach to theology and its strong focus on the poor. Three decades later, it is still considered

groundbreaking,[3] and Gutiérrez himself remains widely acclaimed as the "father of liberation theology."[4] However, in recent years, Gutiérrez's liberation theology has become less significant.

During the 1970s and 1980s, *A Theology of Liberation* received a great deal of attention. It was a major subject of debate and conversation among Catholic and Protestant theologians, liberation movements both inside and outside the Catholic Church, and policymakers across the world (though especially in Latin America).

Much of this attention was because of politics related to the Cold War* (a period of tension from 1947 to 1991 between the United States and its Western allies and the Eastern federation of countries known as the Soviet Union*). In the United States, for instance, during the Cold War religious and political leaders were suspicious of liberation theology because of its associations with Marxism* and communism.* Once tension between the United States and the Soviet Union eased, Gutiérrez's work began both to lose its appeal for socialist* movements, and to seem less threatening to those who opposed Marxist influences.

Many of Gutiérrez's fellow liberation theologians also began to shift their focus away from the key principles in his work. Instead of class struggle and radical change, they now emphasized gradual and practical reform, and human rights issues in general. Poverty is no longer seen as strictly a class issue. It is a matter of "public concern" that has become "incorporated into mainstream church discourse."[5]

While *A Theology of Liberation* may no longer be as significant as it used to be, many of its ideas remain relevant, especially within the Catholic Church. For example, Pope Benedict XVI* and Pope Francis* have both stressed the need to focus on issues of poverty.

Limitations

A Theology of Liberation does not always translate neatly into other contexts. One reason for this is the academic style that Gutiérrez uses, which includes difficult theological concepts. This has limited the book's audience to scholarly and religious readers, and prevented a wider readership from embracing its message.

Another issue with the book's vocabulary is its deeply religious and often specifically Catholic language. Gutiérrez speaks "almost entirely in terms of 'the Church' as no Protestant really can."[6] This makes it less accessible for those in the Protestant world, and for those who identify with non-Christian religious traditions (unlike the Catholic Church, the Protestant tradition within Christianity does not have one leading institute; it is divided over a wide range of autonomous Churches that do not speak with a single voice such as the Vatican can do for the Catholic Church).

Doubts have also been raised about Gutiérrez's focus on the poor. A theology that is mainly concerned with working-class conditions might alienate those who see themselves as middle or upper class.[7] Many Latin Americans who have climbed the social and economic ladder in recent decades do not want to be labeled as poor, and therefore feel ambivalent about embracing a theology that reminds them of their former conditions.

In a number of ways, then, Gutiérrez's text today seems outdated. However, this does not mean it is unimportant. It continues to engage academics, social activists, and religious figures around the world. For many readers, Gutiérrez's insights about oppression and how the Church should engage with real-world issues remain important.

NOTES

1 Leonardo Boff, "The Originality of the Theology of Liberation," in *The Future of Liberation Theology: Essays in Honour of Gustavo Gutiérrez*, ed. Marc H. Ellis and Otto Maduro (Maryknoll, NY: Orbis Books, 1989), 46.

2 Frederick Herzog, "Birth Pangs: Liberation Theology in North America," *Christian Century* (December 15, 1976): 1120–5.

3 John Dear, "Gustavo Gutiérrez and the Preferential Option for the Poor," *National Catholic Reporter* (November 8, 2011), accessed on May 28, 2013, http://ncronline.org/blogs/road-peace/gustavo-Gutiérrez-and-preferential-option-poor.

4 James D. Kirylo, "A Historical Overview of Liberation Theology: Some Implications for the Christian Educator," *Journal of Research on Christian Education* 10, no. 1 (2001): 53–86.

5 Carol A. Drogus, "The Rise and Decline of Liberation Theology: Churches, Faith, and Political Change in Latin America," *Comparative Politics* 27, no. 4 (1995): 471.

6 Frederick Sontag, "Political Violence and Liberation Theology," *Journal of the Evangelical Theological Society* 33, no. 1 (March 1990): 90.

7 Drogus, "The Rise and Decline of Liberation Theology," 470.

PLACE IN THE AUTHOR'S WORK

KEY POINTS

- Gustavo Gutiérrez has dedicated his life to the work of liberation.

- *A Theology of Liberation* is the book for which Gutiérrez is most famous, and it represents his legacy to the Church and to Christian theology.*

- In his later writing, Gutiérrez has clarified and developed the central ideas of A Theology of Liberation.

Positioning

Although Gustavo Gutiérrez wrote *A Theology of Liberation: History, Politics, and Salvation* early in his career, it is considered his most important work. The book has been celebrated as "the most important single treatment of liberation theology*"[1] and is still widely read today.

Prior to its publication in Spanish in 1971, Gutiérrez had produced one other book in addition to a small number of essays and presentations. He presented one of these, "Toward a Theology of Liberation,"[2] at a conference in Peru in 1968. This essay outlined much of the thinking that he would elaborate on in *A Theology of Liberation* a few years later. By comparing the book and this earlier essay, readers can see how Gutiérrez had had time to reflect on his key ideas before writing the book.

In his later works, Gutiérrez continued to develop liberation theology, deepening and expanding it. He considered *A Theology of Liberation* "a love letter to God, to the church and to the people to which I belong. Love remains alive, but it grows deeper and changes its manner of expression."[3] He thus recognized that although its core message remained the same, it could also continue to evolve.

> **"** As the community of Jesus'* disciples, [the Church's mission] is to communicate and bear witness to this total liberation of the human being. **"**
>
> Gustavo Gutiérrez, *The Truth Shall Make You Free: Confrontations*

Integration

Many of the texts that Gutiérrez authored later developed ideas from *A Theology of Liberation*. Among the more well known are: *The Power of the Poor in History: Selected Writings* (1979); *We Drink from Our Own Wells: The Spiritual Journey of a People* (1983); and *On Job: God-Talk and the Suffering of the Innocent* (1986). In these, Gutiérrez wanted to expand the spiritual dimension of his liberation theology, and to extend his argument for the Church to engage with the poor. He believed that spirituality was a way to "have access to the oppressed and faithful people."[4] In Gutiérrez's view, to truly know God meant truly knowing one's neighbors—especially those who were poor. He also wrote pieces that defended his work against allegations of Marxism.*

More recently, Gutiérrez has written about the historical context of Latin America. He became particularly interested in the sixteenth-century Spanish friar Bartolomé de Las Casas,* who stood up for the indigenous population of the Americas during the Spanish colonization. Gutiérrez argues that Las Casas's actions demonstrate that liberation theology has been a part of Latin American history for centuries. The thesis of *A Theology of Liberation*, he continues, was neither innovative nor unorthodox: to practice liberation theology is simply to practice theology.

Significance

None of Gutiérrez's later works has received as much acclaim as *A Theology of Liberation*. However, especially since the end of the Cold War,* interest in the book has waned.

The book's central ideas remain influential, though, resurfacing, for example, when Pope Francis* was elected as head of the Catholic Church* in March 2013.[5] Gutiérrez's discussion of liberation also influences social movements across the world, such as black theology,* which draws on theological sources to support African Americans in their struggle against political, social, economic, and cultural oppression,* and also the Occupy Wall Street* movement, a protest movement that began as a result of banking policies that were responsible for the 2007–8 economic downturn in the United States.

Although Gutiérrez's emphasis on the "poor" has been gradually replaced in academic theology by an emphasis on human rights issues,[6] his original project in *A Theology of Liberation* is still seen as a foundational argument in twentieth-century Christian social thought. Many theologians agree that Gutiérrez permanently changed the Church's agenda, as well as the agendas of scholars of theology. It can even be argued that Gutiérrez's liberation theology has encouraged people to see the Church as an institution with a commitment to real-world problems.

NOTES

1 Robert McAfee Brown, *Gustavo Gutiérrez: An Introduction to Liberation Theology* (Maryknoll, NY: Orbis Books, 1990), 186.

2 Gustavo Gutiérrez, "Toward a Theology of Liberation" (paper presented at a meeting of the National Office for Social Research in Chimbote, Peru, July 1968), in *Essential Writings,* ed. James B. Nickoloff (Maryknoll, NY: Orbis Books, 1996).

3 Gustavo Gutiérrez, *A Theology of Liberation: History, Politics, and Salvation,* trans. and ed. Caridad Inda and John Eagleson (Maryknoll, NY: Orbis Books, 2009), xlvi.

4 Leonardo Boff, "The Originality of the Theology of Liberation," in *The Future of Liberation Theology: Essays in Honour of Gustavo Gutiérrez*, ed. Marc H. Ellis and Otto Maduro (Maryknoll, NY: Orbis Books, 1989), 46.

5 Lizzy Davis, "Pope Francis Declares: 'I Would Like to See a Church that is
 Poor and is for the Poor,'" *Guardian*, March 16, 2013, accessed on May
 28, 2013, http://www.guardian.co.uk/world/2013/mar/16/pope-francis-
 church-poverty.

6 Carol A. Drogus, "The Rise and Decline of Liberation Theology: Churches,
 Faith, and Political Change in Latin America," *Comparative Politics* 27, no.
 4 (1995): 470.

SECTION 3
IMPACT

THE FIRST RESPONSES

KEY POINTS

- The Catholic Church* criticized *A Theology of Liberation* for using Marxist* principles, and it criticized Gutiérrez for trying to politicize the Church.

- Gutiérrez responded that it was important for the Church to work for social justice.

- After the Cold War* ended, Marxism was seen as less of a threat, and Gutiérrez's message became more appealing to mainstream and even conservative Catholic leaders.

Criticism

From the moment it was published, Gustavo Gutiérrez's *A Theology of Liberation: History, Politics, and Salvation* was the subject of heavy criticism. Many critics thought the book was an "uncritical acceptance of a Marxis[m]"[1] that could easily be used to begin a revolution. Furthermore, critics claimed that Gutiérrez had read the Bible selectively to garner support for the economically and politically oppressed.* They argued that the Bible's message was that God loves all people, and claimed that Gutiérrez was unfairly transforming neutral spirituality into class struggle.

The most significant condemnation came from the Vatican, headed by Pope John Paul II,* head of the Catholic Church between 1978 and 2005. Initially, the Church launched a low-profile campaign against those supporting liberation theology;* however, by 1983, the Vatican had launched a full papal investigation into Gutiérrez's work. The investigation was led by Cardinal Joseph Ratzinger, who later became Pope Benedict XVI,* and it resulted

> ❝ Gutierrez's volume represents a 'Catholic sociology' that is both religiously heterodox [not conforming to orthodox interpretations of Christian thought] and sociologically unscientific yet is (or was) enormously influential within the Roman Catholic Church. Put another way, it is useful to analyze *A Theology of Liberation* in order to highlight what a Catholic sociology should not become if it is to be considered orthodox. ❞
>
> Joseph A. Varacalli, "A Catholic Sociological Critique of Gustavo Gutiérrez's *A Theology of Liberation*," *The Catholic Social Science Review*

in two official "Instructions," in which Ratzinger condemned liberation theology. These condemnations critiqued Gutiérrez's use of Marxist social analysis.

In the Latin American Episcopal Conference (CELAM), the conservative Secretary General Alfonso López Trujillo* echoed the Vatican's stance. He claimed that Gutiérrez's liberation theology contradicted the Church's divine authority.[2] For years, Ratzinger and Trujillo opposed Gutiérrez and his fellow liberation theologians, banning them from conferences and dismissing them from important Church positions.

Not all of Gutiérrez's critics were religious. Some in the Western world, among them Ronald Reagan,* president of the United States between 1981 and 1989, were concerned about the spread of Marxist revolutionary movements in the region of Latin America. They feared that Gutiérrez's liberation theology would lead to existing governments being replaced by communist systems.

It is important to view these criticisms against the backdrop of the Cold War. Many liberation theologists claimed to be inspired by Marxist thought, which Western powers such as the United

States largely opposed. The United States and its allies feared that communism in Latin America would allow the Soviet Union*—a federation of communist republics created in the aftermath of the 1917 Russian Revolution—to influence the region. Once the Cold War ended, liberation theology was not seen as such a threat.

Responses

In response to these accusations, Gutiérrez reiterated his argument that the Catholic Church had never been neutral, and neither did God want it to be. The problem was that it had most often sided with those who held power. His opponents were afraid not of political involvement, he argued, but of "political involvement *from the left*."[3]

More importantly, Gutiérrez reaffirmed what he viewed as the real mission of the Church. In *The Truth Shall Make You Free*, one of his major responses to the Vatican's criticism, Gutiérrez argued that the Church should acknowledge social reality and commit to working for justice for all.

In spite of his response, Gutiérrez did adjust his position somewhat as a result of early criticisms. In the revisions he made for the fifteenth-anniversary edition of the book in 1986, Gutiérrez changed one chapter, "Christian Brotherhood and Class Struggle," in which he had originally presented his idea of class struggle as "the division of humanity into oppressors and oppressed."[4] Critics argued that this was divisive and denied God's love for "oppressors." In the anniversary edition, Gutiérrez renamed this chapter "Faith and Social Conflict," and acknowledged the possibility of reconciliation between classes.[5]

Furthermore, Gutiérrez was at pains to emphasize that God's love is universal. He challenged those who had accused him of bias by saying that God's love is "incompatible with the exclusion of any persons, but it is not incompatible with a preferential option for the poorest and most oppressed."[6] Gutiérrez made these changes in the

context of historical events that damaged the credibility of Marxist groups. Atrocities by the guerilla revolutionary group Shining Path* in Peru and the Soviet Union's violent intervention in Afghanistan made it difficult for Gutiérrez to continue to support his work using Marxist ideals.

Conflict and Consensus

As Cold War tensions eased in the late 1980s, so did the fear of liberation theology. Still, Gutiérrez's reputation and that of *A Theology of Liberation* had been damaged, especially with respect to Gutiérrez's authority on the Bible. Many critics still regard Gutiérrez's work as interpreting the Scripture* to support a Marxist agenda.[7]

That said, some of the harshest critics of liberation theology, such as former Pope Benedict XVI, have also expressed support for many of Gutiérrez's concerns with issues such as the Church's obligation to address poverty and oppression. While there is still a lot of debate about the ideas in *A Theology of Liberation,* it is fair to say that they have become important for Christian communities. Although Gutiérrez's concern for social stratification and injustice was radical when he first wrote about it, these issues have become significant even for nonreligious Western leaders.

As a result, *A Theology of Liberation* is widely regarded as a powerful contribution to late-twentieth-century Christian theology*— one that has shaped religious belief and practice in both Catholic and Protestant* communities, and which has opened new lines of inquiry for those who study theology in the academic world.

NOTES

1 Robert McAfee Brown, *Gustavo Gutiérrez: An Introduction to Liberation Theology* (Maryknoll, NY: Orbis Books, 1990), 137.

2 See François Houtart, "Theoretical and Institutional Bases of the Opposition to Liberation Theology," in *The Future of Liberation Theology: Essays in Honor of Gustavo Gutiérrez*, ed. Marc H. Ellis and Otto Maduro (Maryknoll, NY: Orbis Books, 1989), 264.

3 Brown, *Gustavo Gutiérrez*, 136.

4 Gustavo Gutiérrez, *A Theology of Liberation: History, Politics, and Salvation,* trans. and ed. Caridad Inda and John Eagleson (Maryknoll, NY: Orbis Books, 2009), 273.

5 Gutiérrez, *A Theology of Liberation,* 157.

6 Gutiérrez, *A Theology of Liberation,* 160.

7 Joseph A. Varacalli, "A Catholic Sociological Critique of Gustavo Gutiérrez's *A Theology of Liberation*: A Review Essay," *The Catholic Social Science Review* 1 (1996): 181.

MODULE 10
THE EVOLVING DEBATE

KEY POINTS

- Liberation theology* has become both more moderate in its social vision and more focused on concrete action (as opposed to theories).

- Different liberation theologies have emerged in response to the concerns of a range of groups who have experienced oppression,* including black theology,* feminist theology,* and American Indian liberation theology.*

- Gutiérrez's original concerns are widely regarded as being just as urgent today as they were in 1971; one reason the text is no longer considered radical is that so many of its ideas are now broadly accepted.

Uses and Problems

Liberation theology has changed dramatically since Gustavo Gutiérrez published *A Theology of Liberation: History, Politics, and Salvation* in 1971. Today, liberation theology supporters rely less on Marxist* theory. Additionally, while it was initially defined by social scientific and theological arguments for a more socially engaged Church,* liberation theology has today become more focused on practical solutions.

By 1980, grassroots Church activists across Latin America were already encouraging their communities to better serve the poor. These efforts, similar to the later efforts of many of the original liberation theologians, often combined liberation theology with popular religious traditions to solve local problems rather than attempt large-scale social change.[1]

> **❝ In their reach for 'the people,' liberation theologians have also become 'populist': grassroots thinkers and pastors, closer to the mainstream. ❞**
> Jeffrey Klaiber, "Prophets and Populists: Liberation Theology, 1968–1988," *The Americas*

Gutiérrez's call to support the poor has entered mainstream Catholic thought. Prominent Church leaders have begun to demonstrate a commitment to human rights. This is a remarkable development for a Church leadership that had long stressed its neutrality on social and political matters.[2]

Gutiérrez has continued to develop the ideas put forward in *A Theology of Liberation*. With later books such as *Las Casas: In Search of the Poor of Jesus Christ* and *The Power of the Poor in History*, he encouraged readers to closely examine the living conditions of poor inhabitants of Latin America. In his own work as a priest in Lima, and in his Instituto Bartelomé de Las Casas—a Christian outreach organization that supports the poor in Peru—Gutiérrez himself has shifted from a focus on theory to concrete action.

Schools of Thought

Many schools of liberation theology have emerged, such as black and feminist. These writers and theorists share Gustavo Gutiérrez's central idea that faith involves active social engagement. Examples of activists who have sought to translate Gutiérrez's work for new contexts of race, gender, and geography include James Cone,* an American theologian known especially for *A Black Theology of Liberation*; Rosemary Radford Ruether,* the American author of *Sexism and God-Talk: Toward a Feminist Theology*; and the Jewish Studies and liberation theologian Marc H. Ellis.*

This illustrates that liberation theology today addresses a wide

range of concerns. For example, Gutiérrez's ideas helped white theologians in South Africa and their black colleagues collaborate in the struggle against apartheid* (the system of racial segregation in South Africa from 1948 to 1994).[3] The Protestant* Palestinian priest Naim Ateek* considers this in relation to geography; he argues that liberation means people having full autonomy in the lands they inhabit. Ateek believes in both Palestinian statehood and in "preserving the Jewish character of Israel."[4]

Others, including non-Christians, have adapted Gutiérrez's argument to address the specific ways in which particular groups face oppression. African American women, for example, face oppression based on race and gender.[5] Marc H. Ellis presents a Jewish theology of liberation that emphasizes full solidarity with both Israelis and Palestinians. He argues that Jewish thought can help both groups reflect productively on their struggles.[6]

More recently, Gutiérrez's ideas have circulated among migrant theologians. Central to migrant theology is the idea that immigrants must always struggle against the feeling of "being in-between" the societies and cultures of their home and host countries.[7] In this way, Gutiérrez's work remains a vital source of inspiration for many schools of thought.

In Current Scholarship
In 2002, a number of prominent theologians and Church leaders convened at the University of Notre Dame, a Catholic research institution in the United States, to discuss the state of liberation theology. Many agreed that it was time to demonstrate that liberation theology was still relevant. One of the conference's attendees asserted that the theology's "methods and message have taken root in the lives and passions of too many people in too many places and in too many ways"[8] for the movement to fade away.

This opinion prevails among most of Gutiérrez's colleagues and

adherents. These include the Brazilian theologian and proponent of liberation theology Leonardo Boff,* and also younger scholars such as James Nickoloff,* a Catholic theologian and professor. Boff and Nickoloff believe that it is just as important today to heed Gutiérrez's call for solidarity with the poor as it was in 1971.[9] Others want to link Gutiérrez's insights with efforts at social engagement. These include non–Christian thinkers who advocate for faith communities to foster love and forgiveness in broader society.[10]

While Gutiérrez's principles still speak to today's social realities, few active scholars reference *A Theology of Liberation*, though they may cite other works from his large body of work or mention his ideas as part of liberation theology in general. As different liberation theologies emerge across the world, so do disagreements about the issues involved and the level of activism to which liberation theologians are called. Some scholars have criticized liberation theology's "absolutism" (its uncompromising, absolute principles) and its preoccupation with politics,[11] arguing that more attention should be given to other issues that concern the Christian community, such as spiritual freedom and practices of forgiveness. These debates suggest that Gutiérrez continues to be relevant, if sometimes indirectly so.

NOTES

1 Jeffrey L. Klaiber, "Prophets and Populists: Liberation Theology, 1968–1988," *The Americas* 46, no. 1 (1989). 15.

2 Carol A. Drogus, "The Rise and Decline of Liberation Theology: Churches, Faith, and Political Change in Latin America," *Comparative Politics* 27, no. 4 (1995): 471.

3 Peter Walshe, "Christianity and the Anti-Apartheid Struggle: The Prophetic Voice Within Divided Churches," *Christianity in South Africa: Political, Social, and Cultural History* 1997: 383–93.

4 Naim S. Ateek, *Justice, and Only Justice: A Palestinian Theology of Liberation* (Maryknoll, NY: Orbis Books, 1989), 166.

5 See, for instance, Delores S. Williams, *Sisters in the Wilderness: The Challenge of Womanist God-Talk* (Maryknoll, NY: Orbis Books), 1993.

6 Marc H. Ellis, *Toward a Jewish Theology of Liberation: The Challenge of the 21st Century* (Waco, TX: Baylor University Press, 2004), 12, 203–25.

7 Simon C. Kim, "Theology of Context as the Theological Method of Virgilio Elizondo and Gustavo Gutiérrez," PhD diss., Catholic University of America, 2011, 300–8.

8 Allan F. Deck, "Beyond La Pausa," *America* 188 (2003): 20–5.

9 Jamie Manson, "Liberation Theology: an interview with James Nickoloff," *National Catholic Reporter*, April 17, 2013.

10 See, for instance, Mario I. Aguilar, "Religion, Politics and Liberation: A Dialogue between Gustavo Gutiérrez, the 14th Dalai Lama and Gianni Vattimo," *Political Theology* 12, no. 1 (2011): 164–5.

11 Matthew W. Hughey, "Moving Beyond 'Liberation Theology': 'New Transcendentalism' as Critique Positivist-Binary Cultural Logic," *Journal of Religious Thought* (2005): 62.

IMPACT AND INFLUENCE TODAY

KEY POINTS

- *A Theology of Liberation* has powerfully shaped the concerns of Christianity today.

- The social challenges Gutiérrez writes about are still relevant to readers today.

- Although Gutiérrez's message of God's love for the poor has gained broad acceptance, the Vatican remains hesitant to fully embrace liberation theology. *

Position

Gustavo Gutiérrez's *A Theology of Liberation: History, Politics, and Salvation* was considered a radical text when it appeared in 1971, boldly claiming that Christians were obligated to address social injustices, and criticizing the Church for claiming to remain politically neutral. Today, Gutiérrez's ideas are no longer considered radical, even by the Vatican; rather, liberation theology has powerfully shaped the concerns of today's Church. In this sense, *A Theology of Liberation* is important for historical reasons, in that it fundamentally changed the way Christians understood the commitments of a life of faith.

The fact that Gutiérrez's ideas have become mainstream is important. It is true that scholars and Church leaders rarely cite it, but this is because the book's argument now seems commonplace. For example, Pope Benedict XVI* and Pope Francis* have both emphasized the Church's commitment to addressing poverty. During his papacy, Benedict XVI severely criticized the way wealth was distributed, arguing that richer countries "pursue material goods and profits at the expense of others."[1] Pope Francis named

> ❝ How I would like a church that is poor and for the
> poor ... Thinking of the poor, I thought of Francis
> of Assisi. Then I thought of all the wars, as the votes
> were still being counted ... Francis is also the man
> of peace. That is how the name came into my heart:
> Francis of Assisi. For me, he is the man of poverty,
> the man of peace, the man who loves and protects
> creation... ❞
>
> Pope Francis, speaking in London, March 2013

himself after the twelfth-century monk Francis of Assisi, a saint who befriended the poor and who himself became poor in solidarity.[2] Such papal support suggests that the ideas in *A Theology of Liberation* have made a huge difference in Christian thinking.

That said, we should also remember that Gutiérrez was not the only Christian of his time who argued for social justice. And it is also true that the Vatican remains hesitant when it comes to taking an official political position. In the words of Pope Francis, the Church "does not respond to an earthly logic" and "the nature of the church is spiritual, not political."[3] Nevertheless, it is impossible to deny that liberation theology has influenced the way Catholics* talk about poverty.

Interaction

A Theology of Liberation continues to challenge conservative religious figures, especially within the Catholic Church,* who argue that the Church should focus on spirituality and religious revelation rather than on politics. Although former Pope Benedict XVI voiced support for addressing social and political issues,[4] he also directed the Church's focus toward doctrine and tradition. The Brazilian theologian* and priest Leonardo Boff* has lamented the former

pope's lack of attention to matters of "poverty, injustice and threats to the environment."[5] Boff, like Gutiérrez, wants a Church that is actively engaged with contemporary social issues, and that is more interested in transforming systems that impoverish people than in the health of financial markets.

Gutiérrez's work also continues to inspire reform movements outside the Catholic Church. For example, he has challenged capitalist* theories that promote free markets, privately owned goods, and profit making. And we can see Gutiérrez's call to stand in solidarity with those who are poor in the Occupy Wall Street* movement's slogan "We are the 99%," which refers to how wealth is unevenly distributed in the United States. Migrant theologians have also employed Gutiérrez's ideas in addressing the problems of immigrants and their experience of always "being in-between" the divergent societies and cultures of their home and host countries.[6]

The Continuing Debate

Gutiérrez's work does not today receive a great deal of criticism from within the Church, at least in part because his ideas have been widely taken up. However, it is still the subject of debate in academia. Scholars of religion and politics, such as Paul Sigmund,* a professor of political theory and Latin American politics, and Frederick Sontag,* a professor of philosophy, both expressed concern about how preoccupied Gutiérrez is with issues of capitalism and poverty.

Gutiérrez's call for radical change has also been discussed, as some argue that it incites violence.[7] His work has been criticized for being "both religiously heterodox [not conforming to orthodox interpretations of Christian thought] and sociologically unscientific,"[8] confusing important Catholic principles of salvation with political activism, and failing to fully explain the social realities it focuses on.

Gutiérrez's work may also hold less significance today among

the poor Catholic communities in Latin America for whom it was originally intended.[9] Today, the notion of liberation theology is less relevant in these places. Ironically, this drift away from liberation theology in these communities may have occurred because they do not have enough resources to support a long struggle with Catholic Church leaders.

NOTES

1 Benedict XVI, *Caritas in Veritate*, sec. 34, in Angela C. Miceli, "Alternative Foundations: A Dialogue with Modernity and the Papacy of Benedict XVI," *Perspectives on Political Science* 41, no. 1 (2012): 27.

2 Joshua J. McElwee, "Pope Francis: I would love a church that is poor," *National Catholic Reporter*, March 16, 2013, accessed on May 30, 2013, http://ncronline.org/blogs/pope-francis-i-would-love-church-poor.

3 McElwee, "Pope Francis."

4 See, for instance, Miceli, "Alternative Foundations."

5 Leonardo Boff, "Pope Benedict XVI is Leading the Church Astray," *International Press Service*, September 13, 2007, accessed on September 26, 2013, http://www.ipsnews.net/2007/09/pope-benedict-xvi-is-leading-the-church-astray/

6 Simon C. Kim, "Theology of Context as the Theological Method of Virgilio Elizondo and Gustavo Gutiérrez," PhD diss., Catholic University of America, 2011, 300–8.

7 See especially: Paul E. Sigmund, *Liberation Theology at the Crossroads: Democracy or Revolution?* (New York: Oxford University Press, 1990); and Frederick Sontag, "Political Violence and Liberation Theology," *Journal of the Evangelical Theological Society* 33, no. 1 (March 1990): 85–94.

8 Joseph A. Varacalli, "A Catholic Sociological Critique of Gustavo Gutiérrez's *A Theology of Liberation*: A Review Essay," *The Catholic Social Science Review* 1 (1996): 175.

9 Kim, "Theology of Context," 295.

MODULE 12
WHERE NEXT?

KEY POINTS

- *A Theology of Liberation* leaves an enduring legacy among Church leaders, theologians,* and others working for social change.

- Although it is perhaps less relevant than it once was, *A Theology of Liberation* will likely continue to shape the Church's position on various issues, and to energize liberation movements around the world.

- *A Theology of Liberation* made the case that working for social justice and building solidarity with the poor were essential Christian commitments—an argument that has slowly gained broad acceptance.

Potential

In an interview in 2003, over three decades after he wrote *A Theology of Liberation: History, Politics, and Salvation*, Gustavo Gutiérrez commented on the apparent decline of liberation theology:* "Like any other theology, liberation theology is linked to a particular historic moment." He acknowledged that it receives less attention than it once did.

He also argued, however, that many of its core aspects have been incorporated into daily life. For many Latin American Catholics,* active social engagement and solidarity with the poor have become part of their religious identities. Although it is not always called by its name, liberation theology continues to exercise its influence, and to find new expressions in different times and different places.[1]

> ❝ With this pope—a Jesuit and a pope from the Third World—we can breathe happiness. Pope Francis has both the vigor and tenderness that we need to create a new spiritual world. Pope Francis comes with the perspective that many of us in Latin America share. In our churches we do not just discuss theological theories … Our churches work together to support universal causes, causes like human rights, from the perspective of the poor, the destiny of humanity that is suffering, services for people living on the margins. ❞
>
> Leonardo Boff, speaking in Buenos Aires, 2013

These circumstances tell us much about the current state of Gutiérrez's *A Theology of Liberation,* as well as about what it may mean in the future. The book is no longer the subject of intense debate within theology, and it is unlikely to have much of an effect on academia. If scholars are interested in liberation theology, there is a wide range of works beyond Gutiérrez's that they can study.

Still, this does not mean that Gutiérrez and *A Theology of Liberation* are irrelevant. Even if they are cited less frequently today, we must still acknowledge that the growth of liberation theology itself, as well as the language it uses, mean that Gutiérrez's work has been so broadly accepted that it is now recognized as mainstream.

Future Directions
Gutiérrez's ideas continue to reemerge in theology schools and religious communities across the world, especially among those concerned with issues of poverty. According to the Catholic priest and activist John Dear,* liberation movements will continue to form as long as there are social and economic disparities, "from

Latin America to Africa to the Middle East to our own growing 'Occupy Wall Street'* movement."[2]

It is hard to know how successful these movements are and the extent to which they draw from *A Theology of Liberation*. What we can say is that Gutiérrez's major principles, including solidarity with the poor and active religious engagement to empower the oppressed,* are very much alive today. Most recently, these principles have featured statements made by Pope Francis.* Although he supposedly opposes liberation theology, he has often declared his support for those living in poverty.

Moreover, Pope Francis represents the Catholic Church's* growing concern for the poor and the working classes—a concern that largely draws inspiration from liberation theology. According to Leonardo Boff,* Pope Francis "has what it takes to fix a church 'in ruins'" and seeks to build "a church for the world's poor,"[3] just as Gutiérrez advocated in *A Theology of Liberation*. If Pope Francis practices what he preaches, Gutiérrez's work might turn out to be more influential than he could ever have hoped.

Summary

Gustavo Gutiérrez published *A Theology of Liberation* in 1971 during a tumultuous time both for Roman Catholics and for the communities of Latin America. The Roman Catholic Church was struggling with calls for internal reform in the aftermath of the Second Vatican Council,* and Latin America was experiencing a rise of Marxist* revolutionary movements, which sought to replace, sometimes violently, the existing governments. There were also deep tensions between capitalist nations of the West and communist nations of the East, and these global issues influenced events in Latin America.

A Theology of Liberation was an important text in the context of these circumstances, especially for reformist Christian theologians and clergy who argued that the Church should be more socially

engaged. It also inspired social activists in and beyond Latin America. Thus, it played a major role in the important debates of its day, both in the Church and in the world at large.

Even given the many texts on liberation theology available today, *A Theology of Liberation* remains foundational.[4] It captured the tumult of the time in which it was written, and its response to poverty and injustice has influenced many generations. Gutiérrez's central message of God's love for the poor seems to return again and again among Church leaders and communities attempting social or political reform.

The book also stands out for Gutiérrez himself, even though he has written and published a great deal of other work during his lifetime. In an interview, he compared it to a love letter to a wife. While he has changed its language over the years, its central theme of God's special love for those suffering from poverty and oppression has endured.[5] It is likely that this important message, rendered so persuasively in *A Theology of Liberation*, will continue to energize theological thought and movements for social justice for decades to come.

NOTES

1 Daniel Hartnett, "Remembering the Poor: An Interview with Gustavo Gutiérrez," *America* 188, no. 3 (2003): 15.

2 John Dear, "Gustavo Gutiérrez and the Preferential Option for the Poor," *National Catholic Reporter* (November 8, 2011), accessed on May 28, 2013, http://ncronline.org/blogs/road-peace/gustavo-Gutiérrez-and-preferential-option-poor.

3 Jessica Weiss, "Liberation Theology Supporters Say Pope Francis Can Fix Church 'In Ruins,'" *Huffington Post*, April 28, 2013.

4 See, for instance: Marc H. Ellis, *Toward a Jewish Theology of Liberation: The Challenge of the 21st Century* (Waco, TX: Baylor University Press, 2004); or Naim S. Ateek, *Justice, and Only Justice: A Palestinian Theology of Liberation* (Maryknoll, NY: Orbis Books, 1989).

5 Gustavo Gutiérrez, *A Theology of Liberation: History, Politics, and Salvation,* trans. and ed. Caridad Inda and John Eagleson (Maryknoll, NY: Orbis Books, 2009), xlvi.

GLOSSARIES

GLOSSARY OF TERMS

American Indian liberation theology: the use of theological sources to support indigenous peoples in the United States in their struggle for autonomy (self-government).

Apartheid: the political and legal system of racial segregation in South Africa that was put in place in 1948 by the governing National Party and lasted until 1994.

Black theology: the use of theological sources to support African Americans in their struggle against political, social, economic, and cultural oppression.

Capitalism: an economic theory and system in which goods and services are owned by private businesses and the government does not regulate markets. It is often opposed to the ideals of communism.

Catholic Church: also called the Roman Catholic Church, this is the largest branch of Christianity and is headed by the Pope in Rome. The Catholic Church was formed in the fourth century C.E. and since then, several groups have broken with Catholicism to form their own denominations, such as Christian Orthodoxy (formed in the eleventh century) and Protestantism (formed in the sixteenth century).

Catholicism: the largest branch of the Christian faith.

Cold War: a period of political, ideological, and military tension from 1947 to 1991 that existed between the capitalist United States and its Western allies, and the communist Soviet Union and its Eastern allies. This period was marked by the constant fear of nuclear war.

Communism: a social philosophy and system of government in which goods and services are owned by everyone for the sake of the common good, and social classes are eliminated.

Cuban Revolution: a revolutionary movement in Cuba led by Fidel Castro and his 26th of July group to oust the dictator at the time, Fulgencio Batista. Castro headed the new government, which was formed in 1959.

Developing countries: countries in which firm economic and political structures have not yet been established. Formerly referred to (by Gutiérrez in the 1970s and 1980s, for example) as "Third World," this term generally refers to poorer countries in Asia, Latin America, and Africa. The term "Global South" is also often substituted for "developing countries."

Feminist theology: a theology that uses insights from mainstream theology and gender studies to liberate women from sexual oppression and inequality.

Liberation theology: a term coined by Gutiérrez in *A Theology of Liberation* that refers to the idea that Christianity should be understood from the perspective of the poor and oppressed.

Marxism: a political and economic theory concerned with the struggle between classes to control labor and production, and with how the labor classes might be empowered. It is named after Karl Marx (1818–1883), author of *Capital* and *The Communist Manifesto* (the latter with Friedrich Engels). Marx was a German philosopher and economist who is sometimes called the "father of socialism." His ideas also form the basis for most communist systems of government.

New Theology: also referred to by its French name, *Nouvelle Théologie*, this school emerged in the mid-twentieth century in France and Germany. Its supporters urged the Catholic Church to engage with modern life.

Occupy Wall Street: a protest movement that began in 2011 in the financial district of New York City. Protesters set up a small tent city and staged demonstrations in Zuccotti Park in order to protest about the banking policies that were responsible for the 2007–8 economic crash. They also protested against a range of other social and economic policies. The movement gradually spread to other major cities throughout the United States and Europe, but remains primarily focused on the United States.

Oppression: in discussions of social justice, this refers to how some groups of people have less access to resources than other groups because of the system of government or economics under which they live.

Praxis: a term meaning practice, as distinguished from theory. In liberation theology, "praxis" connects the message of the Bible to the reality of the world we live in today. Praxis includes both reflection and action that are conscious of the historical context they are responding to.

Protestantism: the division of Christianity that broke with the Catholic Church during the Protestant Reformation of the sixteenth century. Since then, Protestant traditions have proliferated, resulting in many denominations and communities across the world. These include the Lutheran, Anglican, Methodist, Presbyterian, and Anabaptist denominations, as well as many Pentecostal and non-denominational communities.

Progressive Theology: a term for theological movements that use religious claims and theological traditions to argue for social and political reform.

Scripture: holy Christian texts.

Second Vatican Council, or Vatican II: a gathering of Catholic Church leaders from 1962 to 1965. The conference considered the position of the Catholic Church in the modern world. Some of its key conclusions, such as that the Church needed to be more socially engaged, remain controversial among Catholics even today.

Shining Path: the name for the Communist Party in Peru in 1980. The Shining Path became known for the brutal violence it used in its guerilla war against the standing government.

Socialism: a term describing a political and economic theory of social organization in which the way products are made and distributed is owned and controlled by the community as a whole. In Marxist theory, socialism represents a transitional social state between capitalism and communism.

Soviet Union, or USSR: a kind of "superstate" that existed from 1922 to 1991, centered primarily on Russia and its neighbors in Eastern Europe and the northern half of Asia. It was the communist pole of the Cold War, with the United States as its main "rival." After decades of repression and economic failure, the Soviet Union was formally dissolved in 1991.

Theology: the study of the nature and identity of God, and of the religious claims and beliefs sustained by communities of faith.

PEOPLE MENTIONED IN THE TEXT

José Maria Arguedas (1911–69) was a Peruvian novelist known for his writings about indigenous Andean communities and culture. He and Gutiérrez shared a deep friendship and influenced each other's ideas about Peruvian liberation.

Hugo Assman (1933–2008) was a Brazilian theologian and sociologist. He is best known for his work *Theology from the Praxis of Liberation* and is considered a pioneer of liberation theology in Brazil.

Naim Ateek (b. 1937) is a Palestinian Episcopalian priest and liberation theologian, best known for his work *Justice, and Only Justice: A Palestinian Theology of Liberation*.

Fulgencio Batista (1901–73) was initially elected president of Cuba in 1940 to 1944, though he would later become a dictator from 1952. He was overthrown during the Cuban Revolution of 1959 by the 26th of July movement, led by Fidel Castro.

Pope Benedict XVI (b. 1927) was pope from 2005 until he resigned in 2013. He was born Joseph Ratzinger and, before becoming pope, played a key role in the Vatican's responses to liberation theology as a cardinal in the Roman Catholic Church.

Leonardo Boff (b. 1938) is a Brazilian theologian and Roman Catholic priest who was an early proponent of liberation theology. He is professor emeritus of ethics, philosophy of religion and ecology at the Rio de Janeiro State University.

Bartolomé de Las Casas (c. 1484–1566) was a Dominican friar from Spain and the first Bishop of Chiapas, a state in contemporary Mexico. He became known as the "Protector of the Indians" and for his *A Short Account of the Destruction of the Indies*. Gustavo Gutiérrez wrote about him in *Las Casas: In Search of the Poor of Jesus Christ*.

Jesus Christ (c. 3 B.C.E.–30 C.E.) is the central figure of the Christian religion. The historical person of Jesus Christ conducted a mission of preaching and healing in Palestine around 28–30 C.E., and was believed to be the Son of God by his followers.

James Cone (b. 1938) is an American theologian known for his contributions to black theology, and especially for his book *Black Theology of Liberation* (1970).

Yves Congar (1904–95) was a French Dominican theologian in the Catholic Church who was deeply committed to reforming the Church to better address current world issues. He contributed significantly to the Second Vatican Council and was made a cardinal in 1994.

John Dear (b. 1959) is an American Catholic priest and writer. He is an activist for peace and has written books such as *Disarming the Heart: Toward a Vow of Nonviolence* (1987) and *Jesus the Rebel: Bearer of God's Peace and Justice* (2000).

Marc H. Ellis (b. 1952) is an American scholar of Jewish Studies and a liberation theologian, as well as the author of *Toward a Jewish Theology of Liberation: The Challenge of the 21st Century* (2004).

Pope Francis (b. 1936) was elected the 266th pope of the Roman Catholic Church in March 2013. Born in Argentina, Francis is the first pope from Latin America, and his leadership has steered the Church toward more liberal social and political positions than those of his predecessor, Pope Benedict XVI.

Paulo Freire (1921–97) was a Brazilian writer and educator best known for his work on critical teaching and his book *Pedagogy of the Oppressed* (1968).

Frederick Herzog (1925–95) was an American professor of systematic theology and a minister in the United Church of Christ. He has been known for his support for civil rights and liberation theology.

Jeffrey Klaiber (1943–2014) was a Jesuit priest and a historian of the Church in Latin America. He lived in Lima, Peru for nearly 40 years, working as an educator and priest, and served as a visiting professor at several North American institutions, including Georgetown University and Goshen College.

Henri-Marie de Lubac (1896–1991) was a Jesuit priest from France. He helped shape the Second Vatican Council and became a cardinal in the Catholic Church in 1983. De Lubac is still considered one of the most important theologians of the twentieth century.

José Carlos Mariàtegui (1894–1930) was the co-founder of Peru's Socialist Party, which later became the Communist Party. Mariàtegui became known as one of Latin America's most influential socialists. He was a prolific writer and journalist and is best known for his *Seven Interpretive Essays on Peruvian Reality* (1928).

Karl Marx (1818–83) was a German political philosopher and economist, and the founder of modern communism. His best-known works are the *Communist Manifesto* (with Frederich Engels 1848) and the three-volume work *Das Kapital (Capital)* (1867).

Arthur McGovern was a Jesuit professor of philosophy at the University of Detroit. He authored several books on liberation theology, including *Marxism: An American Christian Perspective* (1990) and *Liberation Theology and Its Critics: Toward an Assessment* (1989).

James Nickoloff is a Catholic theologian and associate professor emeritus of religious studies at the College of the Holy Cross in Worcester, Massachusetts.

Pope John Paul II (1920–2005) presided over the Roman Catholic Church from 1978 until 2005. He was known for supporting the reforms of the Second Vatican Council and for strongly opposing communism. He was critical of liberation theology for, among other reasons, its political affiliations with Marxism.

Ronald Reagan (1911–2004) was the 40th president of the United States, holding office between 1981 and 1989.

Rosemary Radford Ruether (b. 1936) is an American theologian known for her work on feminist theology. Her classic work is *Sexism and God-Talk: Toward a Feminist Theology* (1983).

Juan Luis Segundo (1925–96) was a Jesuit priest from Uruguay and a key figure in Latin American liberation theology. He studied with Gustavo Gutiérrez at the University of Louvain and is known for his work *The Liberation of Theology* (1976).

Paul Sigmund (1929–2014) was professor emeritus at Princeton University. He specialized in political theory and Latin American politics.

Frederick Sontag (1924–2009) was a professor of philosophy with a special interest in religion and theology. Among his many works are *A Kierkegaard Handbook* (1979) and *Sun Myung Moon and the Unification Church* (1977).

Camilo Torres (1929–66) was a Colombian socialist and priest. He fought with the communist guerrilla organization the National Liberation Army against the existing government and was killed in combat. Gutiérrez and Torres had become friends while studying at the University of Louvain.

Alfonso López Trujillo (1935–2008) was a cardinal bishop from Colombia who headed the Latin American Episcopal Conference (CELAM) from 1972 to 1984. CELAM was created in 1955 as a conference of the Roman Catholic bishops of Latin America. Under Trujillo's leadership, it became gradually more conservative and skeptical about both Church reform and liberation theology.

WORKS CITED

WORKS CITED

Aguilar, Mario I. "Religion, Politics and Liberation: A Dialogue between Gustavo Gutiérrez, the 14th Dalai Lama and Gianni Vattimo." *Political Theology* 12, no. 1 (2011): 144–66.

Ateek, Naim S. *Justice, and Only Justice: A Palestinian Theology of Liberation.* Maryknoll, NY: Orbis Books, 1989.

Bell, Daniel M. *Liberation Theology After the End of History: The Refusal to Cease Suffering.* London: Routledge, 2001.

Boff, Leonardo. "Pope Benedict XVI is Leading the Church Astray." *International Press Service*, September 13, 2007, accessed on September 26, 2013, http://www.ipsnews.net/2007/09/pope-benedict-xvi-is-leading-the-church-astray/.

— — —. "The Originality of the Theology of Liberation." In *The Future of Liberation Theology: Essays in Honor of Gustavo Gutiérrez*, edited by Marc H. Ellis and Otto Maduro, 38–48. Maryknoll, NY: Orbis Books, 1989.

Brook, Angus. "Towards a Theology of Liberation." *Theology Papers and Journal Articles* Paper 2 (2008), accessed on May 18, 2013, http://researchonline.nd.edu.au/theo_article/2.

Brown, Robert McAfee. Gustavo Gutiérrez: An Introduction to Liberation Theology. Maryknoll, NY: Orbis Books, 1990.

Cadorette, Curt. From the Heart of the People: The Theology of Gustavo Gutiérrez. Oak Park, IL: Meyer Stone Books, 1988.

Cone, James. *A Black Theology of Liberation*. Maryknoll, NY: Orbis Books, 1970.

Davis, Joseph. "The Movement Toward Mysticism in Gustavo Gutiérrez's Thought: Is This an Open Door to Pentecostal Dialogue?" *Pneuma* 33, no. 1 (2011): 5–24.

Davis, Lizzy. "Pope Francis Declares: 'I Would Like to See a Church that is Poor and is for the Poor.'" *Guardian*, March 16, 2013, accessed on May 28, 2013, http://www.guardian.co.uk/world/2013/mar/16/pope-francis-church-poverty.

Dear, John. "Gustavo Gutiérrez and the Preferential Option for the Poor." *National Catholic Reporter*, November 8, 2011, accessed on May 28, 2013, http://ncronline.org/blogs/road-peace/gustavo-Gutiérrez-and-preferential-option-poor.

Deck, Allan F. "Beyond La Pausa." *America* 188 (2003): 20–5.

Dorraj, Manochehr. "The Crisis of Modernity and Religious Revivalism: A Comparative Study of Islamic Fundamentalism, Jewish Fundamentalism and Liberation Theology." *Social Compass* 46, no. 2 (1999): 225–40.

Dorrien, Gary J. *Reconstructing the Common Good: Theology and the Social Order*. Maryknoll, New York: Orbis Books, 1990.

Drogus, Carol A. "The Rise and Decline of Liberation Theology: Churches, Faith, and Political Change in Latin America." *Comparative Politics* 27, no. 4 (1995): 465–77.

du Plessix Gray, Francine. *Divine Disobedience: Profiles in Catholic Radicalism*. New York: Knopf, 1970.

Ellis, Marc H. *Toward a Jewish Theology of Liberation: The Challenge of the 21st Century*. Waco, TX: Baylor University Press, 2004.

Ellis, Marc H. and Maduro, Otto. *The Future of Liberation Theology: Essays in Honor of Gustavo Gutiérrez*. Maryknoll, NY: Orbis Books, 1989.

Goodstein, Laurie. "Pentecostal and Charismatic Groups Growing." *The New York Times*, October 6, 2006.

Gutiérrez, Gustavo. *Las Casas: In Search of the Poor of Jesus Christ*. Maryknoll, NY: Orbis Books, 1993.

———. *Essential Writings*, edited by James B. Nickoloff. Maryknoll, NY: Orbis Books, 1996.

———. *The God of Life*. University of Michigan: Orbis Books, 1991.

———. *On Job: God-Talk and the Suffering of the Innocent*. Maryknoll, NY: Orbis Books, 1986.

———. *The Power of the Poor in History: Selected Writings*. Maryknoll, NY: Orbis Books, 1983.

———. *A Theology of Liberation: History, Politics, and Salvation*. Maryknoll, NY: Orbis Books, 1973.

———. *Theology of Liberation: History, Politics, and Salvation*, translated and edited by Caridad Inda and John Eagleson. Maryknoll, NY: Orbis Books, 2009.

———. *A Theology of Liberation: History, Politics, and Salvation 15th Anniversary Edition with a new introduction by the author*. Translated and edited by Sister Caridad Inda and John Eagleson. Maryknoll, NY: Orbis Books, 1988.

———. "The Theology of Liberation: Perspectives and Tasks." In *Toward a New Heaven and a New Earth: Essays in Honor of Elisabeth Schüssler*

Fiorenza, edited by Fernando F. Segonia, 287–99. Maryknoll, NY: Orbis Books, 2003.

— — —. *The Truth Shall Make You Free: Confrontations*. Maryknoll, NY: Orbis Books, 1990.

— — —. *We Drink from Our Own Wells: The Spiritual Journey of a People.* Maryknoll, NY: Orbis Books, 1983.

Hartnett, Daniel. "Remembering the Poor: An Interview with Gustavo Gutiérrez." *America* 188, no. 3 (2003): 12–16.

Herzog, Frederick. "Birth Pangs: Liberation Theology in North America." *Christian Century*, December 15, 1976, 1120–5.

Houtart, François. "Theoretical and Institutional Bases of the Opposition to Liberation Theology." In *The Future of Liberation Theology: Essays in Honor of Gustavo Gutiérrez*, edited by Marc H. Ellis and Otto Maduro, 261–70. Maryknoll, NY: Orbis Books, 1989.

Hughey, Matthew W. "Moving Beyond 'Liberation Theology': 'New Transcendentalism' as Critique Positivist-Binary Cultural Logic." *Journal of Religious Thought* 2005: 39–66.

"Instruction on Certain Aspects of the *Theology of Liberation*," IX.2–3. Given at Rome, at the Sacred Congregation for the Doctrine of the Faith, on August 6, 1984, accessed May 30, 2013, http://www.vatican.va/roman_curia/congregations/cfaith/documents/rc_con_cfaith_doc_19840806_theology-liberation_en.html.

Kim, Simon C. "Theology of Context as the Theological Method of Virgilio Elizondo and Gustavo Gutiérrez." PhD diss., Catholic University of America, 2011.

Klaiber, Jeffrey L. "Prophets and Populists: Liberation Theology, 1968–1988." *The Americas* 46, no. 1 (1989): 1–15.

Kirylo, James D. "A Historical Overview of Liberation Theology: Some Implications for the Christian Educator." *Journal of Research on Christian Education* 10, no. 1 (2001): 53–86.

Levine, Daniel H. "Assessing the Impacts of Liberation Theology in Latin America." *Review of Politics* 50, no. 2 (1988): 241–63.

Lewis, Thomas A. "Actions as the Ties That Bind: Love, Praxis, and Community in the Thought of Gustavo Gutiérrez." *Journal of Religious Ethics* 33, no. 3 (2005): 539–67.

Manson, Jamie. "Liberation Theology: An Interview with James Nickoloff." *National Catholic Reporter*, April 17, 2013.

Miceli, Angela C. "Alternative Foundations: A Dialogue with Modernity and the Papacy of Benedict XVI." *Perspectives on Political Science* 41, no. 1 (2012): 19–29.

McElwee, Joshua J. "Pope Francis: I would love a church that is poor." *National Catholic Reporter*, March 16, 2013, accessed on May 30, 2013, http://ncronline.org/blogs/pope-francis-i-would-love-church-poor.

McGovern, Arthur. "Dependency Theory, Marxist Analysis, and Liberation Theology." In *The Future of Liberation Theology: Essays in Honor of Gustavo Gutiérrez*, edited by Marc H. Ellis and Otto Maduro, 272–86. Maryknoll, NY: Orbis Books, 1989.

McGovern, Arthur. *Liberation Theology and its Critics: Toward an Assessment.* Maryknoll, NY: Orbis Books, 1989.

Ruether, Rosemary Radford. *Sexism and God-Talk: Toward a Feminist Theology*. Boston: Beacon Press, 1983.

Sigmund, Paul E. *Liberation Theology at the Crossroads: Democracy or Revolution?* New York: Oxford University Press, 1990.

———. "Gustavo Gutiérrez." In *The Teachings of Modern Christianity on Law, Politics, and Human Nature*, edited by John Witte and Frank S. Alexander. New York: Columbia University Press, 2006.

Smith, Christian. *The Emergence of Liberation Theology: Radical Religion and Social Movement Theory*. Chicago: University of Chicago Press, 1991.

Sontag, Frederick. "Political Violence and Liberation Theology." *Journal of the Evangelical Theological Society* 33, no. 1 (March 1990): 85–94.

Tinker, George E. *American Indian Liberation: A Theology of Sovereignty*. Maryknoll, NY: Orbis Books, 2008.

———. *Spirit and Resistance: Political Theology and American Indian Liberation*. Minneapolis: Fortress Press, 2004.

Torres, Sergio. "Gustavo Gutiérrez: A Historical Sketch." In *The Future of Liberation Theology: Essays in Honor of Gustavo Gutiérrez*, edited by Marc H. Ellis and Otto Maduro, 95–101. Maryknoll, NY: Orbis Books, 1989.

Varacalli, Joseph A. "A Catholic Sociological Critique of Gustavo Gutiérrez's *A Theology of Liberation*: A Review Essay." *The Catholic Social Science Review* 1 (1996): 175–89.

Walshe, Peter. "Christianity and the Anti-Apartheid Struggle: The Prophetic Voice within Divided Churches." In *Christianity in South Africa: Political, Social, and Cultural History*, edited by Richard Elphick and T.R.H. Davenport, 383–93. Berkeley: University of California Press, 1997.

Weiss, Jessica. "Liberation Theology Supporters Say Pope Francis Can Fix Church 'In Ruins.'" *Huffington Post*, April 28, 2013.

Williams, Delores S. *Sisters in the Wilderness: The Challenge of Womanist God-Talk*. Maryknoll, NY: Orbis Books, 1993.

Wilson, James F. *Liberation Theology: Is There a Future for It?* Fort Belvoir, VA: Defense Technical Information Center, 1993.

THE MACAT LIBRARY
BY DISCIPLINE

The Macat Library By Discipline

AFRICANA STUDIES

Chinua Achebe's *An Image of Africa: Racism in Conrad's Heart of Darkness*
W. E. B. Du Bois's *The Souls of Black Folk*
Zora Neale Huston's *Characteristics of Negro Expression*
Martin Luther King Jr's *Why We Can't Wait*
Toni Morrison's *Playing in the Dark: Whiteness in the American Literary Imagination*

ANTHROPOLOGY

Arjun Appadurai's *Modernity at Large: Cultural Dimensions of Globalisation*
Philippe Ariès's *Centuries of Childhood*
Franz Boas's *Race, Language and Culture*
Kim Chan & Renée Mauborgne's *Blue Ocean Strategy*
Jared Diamond's *Guns, Germs & Steel: the Fate of Human Societies*
Jared Diamond's *Collapse: How Societies Choose to Fail or Survive*
E. E. Evans-Pritchard's *Witchcraft, Oracles and Magic Among the Azande*
James Ferguson's *The Anti-Politics Machine*
Clifford Geertz's *The Interpretation of Cultures*
David Graeber's *Debt: the First 5000 Years*
Karen Ho's *Liquidated: An Ethnography of Wall Street*
Geert Hofstede's *Culture's Consequences: Comparing Values, Behaviors, Institutes and Organizations across Nations*
Claude Lévi-Strauss's *Structural Anthropology*
Jay Macleod's *Ain't No Makin' It: Aspirations and Attainment in a Low-Income Neighborhood*
Saba Mahmood's *The Politics of Piety: The Islamic Revival and the Feminist Subject*
Marcel Mauss's *The Gift*

BUSINESS

Jean Lave & Etienne Wenger's *Situated Learning*
Theodore Levitt's *Marketing Myopia*
Burton G. Malkiel's *A Random Walk Down Wall Street*
Douglas McGregor's *The Human Side of Enterprise*
Michael Porter's *Competitive Strategy: Creating and Sustaining Superior Performance*
John Kotter's *Leading Change*
C. K. Prahalad & Gary Hamel's *The Core Competence of the Corporation*

CRIMINOLOGY

Michelle Alexander's *The New Jim Crow: Mass Incarceration in the Age of Colorblindness*
Michael R. Gottfredson & Travis Hirschi's *A General Theory of Crime*
Richard Herrnstein & Charles A. Murray's *The Bell Curve: Intelligence and Class Structure in American Life*
Elizabeth Loftus's *Eyewitness Testimony*
Jay Macleod's *Ain't No Makin' It: Aspirations and Attainment in a Low-Income Neighborhood*
Philip Zimbardo's *The Lucifer Effect*

ECONOMICS

Janet Abu-Lughod's *Before European Hegemony*
Ha-Joon Chang's *Kicking Away the Ladder*
David Brion Davis's *The Problem of Slavery in the Age of Revolution*
Milton Friedman's *The Role of Monetary Policy*
Milton Friedman's *Capitalism and Freedom*
David Graeber's *Debt: the First 5000 Years*
Friedrich Hayek's *The Road to Serfdom*
Karen Ho's *Liquidated: An Ethnography of Wall Street*

John Maynard Keynes's *The General Theory of Employment, Interest and Money*
Charles P. Kindleberger's *Manias, Panics and Crashes*
Robert Lucas's *Why Doesn't Capital Flow from Rich to Poor Countries?*
Burton G. Malkiel's *A Random Walk Down Wall Street*
Thomas Robert Malthus's *An Essay on the Principle of Population*
Karl Marx's *Capital*
Thomas Piketty's *Capital in the Twenty-First Century*
Amartya Sen's *Development as Freedom*
Adam Smith's *The Wealth of Nations*
Nassim Nicholas Taleb's *The Black Swan: The Impact of the Highly Improbable*
Amos Tversky's & Daniel Kahneman's *Judgment under Uncertainty: Heuristics and Biases*
Mahbub Ul Haq's *Reflections on Human Development*
Max Weber's *The Protestant Ethic and the Spirit of Capitalism*

FEMINISM AND GENDER STUDIES

Judith Butler's *Gender Trouble*
Simone De Beauvoir's *The Second Sex*
Michel Foucault's *History of Sexuality*
Betty Friedan's *The Feminine Mystique*
Saba Mahmood's *The Politics of Piety: The Islamic Revival and the Feminist Subjec*t
Joan Wallach Scott's *Gender and the Politics of History*
Mary Wollstonecraft's *A Vindication of the Rights of Woman*
Virginia Woolf's *A Room of One's Own*

GEOGRAPHY

The Brundtland Report's *Our Common Future*
Rachel Carson's *Silent Spring*
Charles Darwin's *On the Origin of Species*
James Ferguson's *The Anti-Politics Machine*
Jane Jacobs's *The Death and Life of Great American Cities*
James Lovelock's *Gaia: A New Look at Life on Earth*
Amartya Sen's *Development as Freedom*
Mathis Wackernagel & William Rees's *Our Ecological Footprint*

HISTORY

Janet Abu-Lughod's *Before European Hegemony*
Benedict Anderson's *Imagined Communities*
Bernard Bailyn's *The Ideological Origins of the American Revolution*
Hanna Batatu's *The Old Social Classes And The Revolutionary Movements Of Iraq*
Christopher Browning's *Ordinary Men: Reserve Police Batallion 101 and the Final Solution in Poland*
Edmund Burke's *Reflections on the Revolution in France*
William Cronon's *Nature's Metropolis: Chicago And The Great West*
Alfred W. Crosby's *The Columbian Exchange*
Hamid Dabashi's *Iran: A People Interrupted*
David Brion Davis's *The Problem of Slavery in the Age of Revolution*
Nathalie Zemon Davis's *The Return of Martin Guerre*
Jared Diamond's *Guns, Germs & Steel: the Fate of Human Societies*
Frank Dikotter's *Mao's Great Famine*
John W Dower's *War Without Mercy: Race And Power In The Pacific War*
W. E. B. Du Bois's *The Souls of Black Folk*
Richard J. Evans's *In Defence of History*
Lucien Febvre's *The Problem of Unbelief in the 16th Century*
Sheila Fitzpatrick's *Everyday Stalinism*

The Macat Library By Discipline

Eric Foner's *Reconstruction: America's Unfinished Revolution, 1863-1877*
Michel Foucault's *Discipline and Punish*
Michel Foucault's *History of Sexuality*
Francis Fukuyama's *The End of History and the Last Man*
John Lewis Gaddis's *We Now Know: Rethinking Cold War History*
Ernest Gellner's *Nations and Nationalism*
Eugene Genovese's *Roll, Jordan, Roll: The World the Slaves Made*
Carlo Ginzburg's *The Night Battles*
Daniel Goldhagen's *Hitler's Willing Executioners*
Jack Goldstone's *Revolution and Rebellion in the Early Modern World*
Antonio Gramsci's *The Prison Notebooks*
Alexander Hamilton, John Jay & James Madison's *The Federalist Papers*
Christopher Hill's *The World Turned Upside Down*
Carole Hillenbrand's *The Crusades: Islamic Perspectives*
Thomas Hobbes's *Leviathan*
Eric Hobsbawm's *The Age Of Revolution*
John A. Hobson's *Imperialism: A Study*
Albert Hourani's *History of the Arab Peoples*
Samuel P. Huntington's *The Clash of Civilizations and the Remaking of World Order*
C. L. R. James's *The Black Jacobins*
Tony Judt's *Postwar: A History of Europe Since 1945*
Ernst Kantorowicz's *The King's Two Bodies: A Study in Medieval Political Theology*
Paul Kennedy's *The Rise and Fall of the Great Powers*
Ian Kershaw's *The "Hitler Myth": Image and Reality in the Third Reich*
John Maynard Keynes's *The General Theory of Employment, Interest and Money*
Charles P. Kindleberger's *Manias, Panics and Crashes*
Martin Luther King Jr's *Why We Can't Wait*
Henry Kissinger's *World Order: Reflections on the Character of Nations and the Course of History*
Thomas Kuhn's *The Structure of Scientific Revolutions*
Georges Lefebvre's *The Coming of the French Revolution*
John Locke's *Two Treatises of Government*
Niccolò Machiavelli's *The Prince*
Thomas Robert Malthus's *An Essay on the Principle of Population*
Mahmood Mamdani's *Citizen and Subject: Contemporary Africa And The Legacy Of Late Colonialism*
Karl Marx's *Capital*
Stanley Milgram's *Obedience to Authority*
John Stuart Mill's *On Liberty*
Thomas Paine's *Common Sense*
Thomas Paine's *Rights of Man*
Geoffrey Parker's *Global Crisis: War, Climate Change and Catastrophe in the Seventeenth Century*
Jonathan Riley-Smith's *The First Crusade and the Idea of Crusading*
Jean-Jacques Rousseau's *The Social Contract*
Joan Wallach Scott's *Gender and the Politics of History*
Theda Skocpol's *States and Social Revolutions*
Adam Smith's *The Wealth of Nations*
Timothy Snyder's *Bloodlands: Europe Between Hitler and Stalin*
Sun Tzu's *The Art of War*
Keith Thomas's *Religion and the Decline of Magic*
Thucydides's *The History of the Peloponnesian War*
Frederick Jackson Turner's *The Significance of the Frontier in American History*
Odd Arne Westad's *The Global Cold War: Third World Interventions And The Making Of Our Times*

LITERATURE

Chinua Achebe's *An Image of Africa: Racism in Conrad's Heart of Darkness*
Roland Barthes's *Mythologies*
Homi K. Bhabha's *The Location of Culture*
Judith Butler's *Gender Trouble*
Simone De Beauvoir's *The Second Sex*
Ferdinand De Saussure's *Course in General Linguistics*
T. S. Eliot's *The Sacred Wood: Essays on Poetry and Criticism*
Zora Neale Huston's *Characteristics of Negro Expression*
Toni Morrison's *Playing in the Dark: Whiteness in the American Literary Imagination*
Edward Said's *Orientalism*
Gayatri Chakravorty Spivak's *Can the Subaltern Speak?*
Mary Wollstonecraft's *A Vindication of the Rights of Women*
Virginia Woolf's *A Room of One's Own*

PHILOSOPHY

Elizabeth Anscombe's *Modern Moral Philosophy*
Hannah Arendt's *The Human Condition*
Aristotle's *Metaphysics*
Aristotle's *Nicomachean Ethics*
Edmund Gettier's *Is Justified True Belief Knowledge?*
Georg Wilhelm Friedrich Hegel's *Phenomenology of Spirit*
David Hume's *Dialogues Concerning Natural Religion*
David Hume's *The Enquiry for Human Understanding*
Immanuel Kant's *Religion within the Boundaries of Mere Reason*
Immanuel Kant's *Critique of Pure Reason*
Søren Kierkegaard's *The Sickness Unto Death*
Søren Kierkegaard's *Fear and Trembling*
C. S. Lewis's *The Abolition of Man*
Alasdair MacIntyre's *After Virtue*
Marcus Aurelius's *Meditations*
Friedrich Nietzsche's *On the Genealogy of Morality*
Friedrich Nietzsche's *Beyond Good and Evil*
Plato's *Republic*
Plato's *Symposium*
Jean-Jacques Rousseau's *The Social Contract*
Gilbert Ryle's *The Concept of Mind*
Baruch Spinoza's *Ethics*
Sun Tzu's *The Art of War*
Ludwig Wittgenstein's *Philosophical Investigations*

POLITICS

Benedict Anderson's *Imagined Communities*
Aristotle's *Politics*
Bernard Bailyn's *The Ideological Origins of the American Revolution*
Edmund Burke's *Reflections on the Revolution in France*
John C. Calhoun's *A Disquisition on Government*
Ha-Joon Chang's *Kicking Away the Ladder*
Hamid Dabashi's *Iran: A People Interrupted*
Hamid Dabashi's *Theology of Discontent: The Ideological Foundation of the Islamic Revolution in Iran*
Robert Dahl's *Democracy and its Critics*
Robert Dahl's *Who Governs?*
David Brion Davis's *The Problem of Slavery in the Age of Revolution*

The Macat Library By Discipline

Alexis De Tocqueville's *Democracy in America*
James Ferguson's *The Anti-Politics Machine*
Frank Dikotter's *Mao's Great Famine*
Sheila Fitzpatrick's *Everyday Stalinism*
Eric Foner's *Reconstruction: America's Unfinished Revolution, 1863-1877*
Milton Friedman's *Capitalism and Freedom*
Francis Fukuyama's *The End of History and the Last Man*
John Lewis Gaddis's *We Now Know: Rethinking Cold War History*
Ernest Gellner's *Nations and Nationalism*
David Graeber's *Debt: the First 5000 Years*
Antonio Gramsci's *The Prison Notebooks*
Alexander Hamilton, John Jay & James Madison's *The Federalist Papers*
Friedrich Hayek's *The Road to Serfdom*
Christopher Hill's *The World Turned Upside Down*
Thomas Hobbes's *Leviathan*
John A. Hobson's *Imperialism: A Study*
Samuel P. Huntington's *The Clash of Civilizations and the Remaking of World Order*
Tony Judt's *Postwar: A History of Europe Since 1945*
David C. Kang's *China Rising: Peace, Power and Order in East Asia*
Paul Kennedy's *The Rise and Fall of Great Powers*
Robert Keohane's *After Hegemony*
Martin Luther King Jr.'s *Why We Can't Wait*
Henry Kissinger's *World Order: Reflections on the Character of Nations and the Course of History*
John Locke's *Two Treatises of Government*
Niccolò Machiavelli's *The Prince*
Thomas Robert Malthus's *An Essay on the Principle of Population*
Mahmood Mamdani's *Citizen and Subject: Contemporary Africa And The Legacy Of Late Colonialism*
Karl Marx's *Capital*
John Stuart Mill's *On Liberty*
John Stuart Mill's *Utilitarianism*
Hans Morgenthau's *Politics Among Nations*
Thomas Paine's *Common Sense*
Thomas Paine's *Rights of Man*
Thomas Piketty's *Capital in the Twenty-First Century*
Robert D. Putman's *Bowling Alone*
John Rawls's *Theory of Justice*
Jean-Jacques Rousseau's *The Social Contract*
Theda Skocpol's *States and Social Revolutions*
Adam Smith's *The Wealth of Nations*
Sun Tzu's *The Art of War*
Henry David Thoreau's *Civil Disobedience*
Thucydides's *The History of the Peloponnesian War*
Kenneth Waltz's *Theory of International Politics*
Max Weber's *Politics as a Vocation*
Odd Arne Westad's *The Global Cold War: Third World Interventions And The Making Of Our Times*

POSTCOLONIAL STUDIES

Roland Barthes's *Mythologies*
Frantz Fanon's *Black Skin, White Masks*
Homi K. Bhabha's *The Location of Culture*
Gustavo Gutiérrez's *A Theology of Liberation*
Edward Said's *Orientalism*
Gayatri Chakravorty Spivak's *Can the Subaltern Speak?*

PSYCHOLOGY

Gordon Allport's *The Nature of Prejudice*
Alan Baddeley & Graham Hitch's *Aggression: A Social Learning Analysis*
Albert Bandura's *Aggression: A Social Learning Analysis*
Leon Festinger's *A Theory of Cognitive Dissonance*
Sigmund Freud's *The Interpretation of Dreams*
Betty Friedan's *The Feminine Mystique*
Michael R. Gottfredson & Travis Hirschi's *A General Theory of Crime*
Eric Hoffer's *The True Believer: Thoughts on the Nature of Mass Movements*
William James's *Principles of Psychology*
Elizabeth Loftus's *Eyewitness Testimony*
A. H. Maslow's *A Theory of Human Motivation*
Stanley Milgram's *Obedience to Authority*
Steven Pinker's *The Better Angels of Our Nature*
Oliver Sacks's *The Man Who Mistook His Wife For a Hat*
Richard Thaler & Cass Sunstein's *Nudge: Improving Decisions About Health, Wealth and Happiness*
Amos Tversky's *Judgment under Uncertainty: Heuristics and Biases*
Philip Zimbardo's *The Lucifer Effect*

SCIENCE

Rachel Carson's *Silent Spring*
William Cronon's *Nature's Metropolis: Chicago And The Great West*
Alfred W. Crosby's *The Columbian Exchange*
Charles Darwin's *On the Origin of Species*
Richard Dawkin's *The Selfish Gene*
Thomas Kuhn's *The Structure of Scientific Revolutions*
Geoffrey Parker's *Global Crisis: War, Climate Change and Catastrophe in the Seventeenth Century*
Mathis Wackernagel & William Rees's *Our Ecological Footprint*

SOCIOLOGY

Michelle Alexander's *The New Jim Crow: Mass Incarceration in the Age of Colorblindness*
Gordon Allport's *The Nature of Prejudice*
Albert Bandura's *Aggression: A Social Learning Analysis*
Hanna Batatu's *The Old Social Classes And The Revolutionary Movements Of Iraq*
Ha-Joon Chang's *Kicking Away the Ladder*
W. E. B. Du Bois's *The Souls of Black Folk*
Émile Durkheim's *On Suicide*
Frantz Fanon's *Black Skin, White Masks*
Frantz Fanon's *The Wretched of the Earth*
Eric Foner's *Reconstruction: America's Unfinished Revolution, 1863-1877*
Eugene Genovese's *Roll, Jordan, Roll: The World the Slaves Made*
Jack Goldstone's *Revolution and Rebellion in the Early Modern World*
Antonio Gramsci's *The Prison Notebooks*
Richard Herrnstein & Charles A Murray's *The Bell Curve: Intelligence and Class Structure in American Life*
Eric Hoffer's *The True Believer: Thoughts on the Nature of Mass Movements*
Jane Jacobs's *The Death and Life of Great American Cities*
Robert Lucas's *Why Doesn't Capital Flow from Rich to Poor Countries?*
Jay Macleod's *Ain't No Makin' It: Aspirations and Attainment in a Low Income Neighborhood*
Elaine May's *Homeward Bound: American Families in the Cold War Era*
Douglas McGregor's *The Human Side of Enterprise*
C. Wright Mills's *The Sociological Imagination*

The Macat Library By Discipline

Thomas Piketty's *Capital in the Twenty-First Century*
Robert D. Putman's *Bowling Alone*
David Riesman's *The Lonely Crowd: A Study of the Changing American Character*
Edward Said's *Orientalism*
Joan Wallach Scott's *Gender and the Politics of History*
Theda Skocpol's *States and Social Revolutions*
Max Weber's *The Protestant Ethic and the Spirit of Capitalism*

THEOLOGY

Augustine's *Confessions*
Benedict's *Rule of St Benedict*
Gustavo Gutiérrez's *A Theology of Liberation*
Carole Hillenbrand's *The Crusades: Islamic Perspectives*
David Hume's *Dialogues Concerning Natural Religion*
Immanuel Kant's *Religion within the Boundaries of Mere Reason*
Ernst Kantorowicz's *The King's Two Bodies: A Study in Medieval Political Theology*
Søren Kierkegaard's *The Sickness Unto Death*
C. S. Lewis's *The Abolition of Man*
Saba Mahmood's *The Politics of Piety: The Islamic Revival and the Feminist Subject*
Baruch Spinoza's *Ethics*
Keith Thomas's *Religion and the Decline of Magic*

COMING SOON

Chris Argyris's *The Individual and the Organisation*
Seyla Benhabib's *The Rights of Others*
Walter Benjamin's *The Work Of Art in the Age of Mechanical Reproduction*
John Berger's *Ways of Seeing*
Pierre Bourdieu's *Outline of a Theory of Practice*
Mary Douglas's *Purity and Danger*
Roland Dworkin's *Taking Rights Seriously*
James G. March's *Exploration and Exploitation in Organisational Learning*
Ikujiro Nonaka's *A Dynamic Theory of Organizational Knowledge Creation*
Griselda Pollock's *Vision and Difference*
Amartya Sen's *Inequality Re-Examined*
Susan Sontag's *On Photography*
Yasser Tabbaa's *The Transformation of Islamic Art*
Ludwig von Mises's *Theory of Money and Credit*

Macat Disciplines

Access the greatest ideas and thinkers across entire disciplines, including

Postcolonial Studies

Roland Barthes's *Mythologies*
Frantz Fanon's *Black Skin, White Masks*
Homi K. Bhabha's *The Location of Culture*
Gustavo Gutiérrez's *A Theology of Liberation*
Edward Said's *Orientalism*
Gayatri Chakravorty Spivak's *Can the Subaltern Speak?*

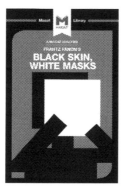

Macat analyses are available from all good bookshops and libraries.

Access hundreds of analyses through one, multimedia tool.

Join free for one month **library.macat.com**

Macat Disciplines

Access the greatest ideas and thinkers across entire disciplines, including

AFRICANA STUDIES

Chinua Achebe's *An Image of Africa: Racism in Conrad's Heart of Darkness*

W. E. B. Du Bois's *The Souls of Black Folk*

Zora Neale Hurston's *Characteristics of Negro Expression*

Martin Luther King Jr.'s *Why We Can't Wait*

Toni Morrison's *Playing in the Dark: Whiteness in the American Literary Imagination*

Macat analyses are available from all good bookshops and libraries.

Access hundreds of analyses through one, multimedia tool.

Macat Disciplines

Access the greatest ideas and thinkers across entire disciplines, including

FEMINISM, GENDER AND QUEER STUDIES

Simone De Beauvoir's
The Second Sex

Michel Foucault's
History of Sexuality

Betty Friedan's
The Feminine Mystique

Saba Mahmood's
*The Politics of Piety:
The Islamic Revival and
the Feminist Subject*

Joan Wallach Scott's
*Gender and the
Politics of History*

Mary Wollstonecraft's
*A Vindication of the
Rights of Woman*

Virginia Woolf's
A Room of One's Own

Judith Butler's
Gender Trouble

Macat analyses are available from all good bookshops and libraries.

Access hundreds of analyses through one, multimedia tool.
Join free for one month **library.macat.com**

Printed in the United States
by Baker & Taylor Publisher Services